People's Lives

A Photographic Celebration of the Human Spirit

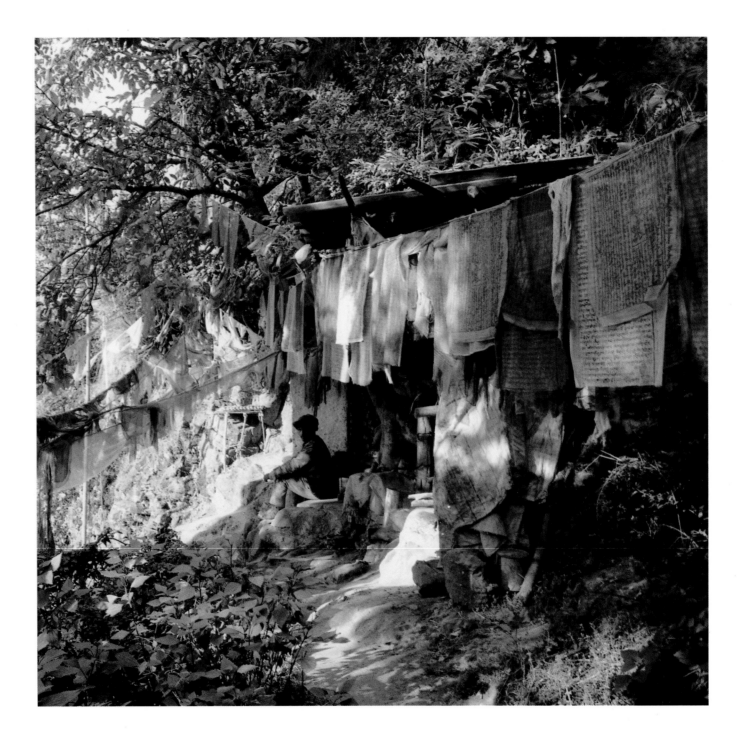

Bill Wright

People's Lives

A Photographic Celebration of the Human Spirit

Introduction by Sam Abell

 University of Texas Press, Austin

Frontispiece: **Temple Guardian,** Nepal, 1990

First edition, 2001

Requests for permission to reproduce material
from this work should be sent to Permissions,
University of Texas Press, Box 7819,
Austin, TX 78713-7819.

∞ The paper used in this book meets the
minimum requirements of ANSI/NISO Z39.48-
1992 (R1997) (Permanence of Paper).

Library of Congress Cataloging-in-Publication Data

Wright, Bill, 1933–
 People's lives : a photographic celebration of
the human spirit / Bill Wright ; introduction by
Sam Abell. — 1st ed.
 p. cm.
ISBN 0-292-79137-2 (hardcover : alk. paper) —
 1. Portrait photography. 2. Wright, Bill, 1933–
 I. Title.
 TR680 .W75 2001
 779'.2'092—dc21 00-008800

Design and typography by George Lenox

To Alice, *my wife of almost 50 years,*
a sensitive photographer,
an honest critic, and a wonderful companion
with whom I have made most of my travels
and without whom
this book would never have been possible

We shall not cease from exploration
And the end of our exploring
Will be to arrive where we started
And know the place for the first time.

T. S. Eliot, "Little Gidding," 1942

Preface

This is a book about the people I have encountered as I traveled in more than fifty countries around the world. I have photographed them in all situations: at their work, in their homes, at play. In the process of passing through their lives, even briefly, I developed an emotional connection with many of them, remembering our conversations and the situations in which we met, writing letters, and exchanging visits. I never turn them loose.

I always try to send a photograph to the people who become my subjects, if they will give me their names and addresses. Often they will, and we enter into a communication that lasts through the years. I get Christmas cards from Israel and China, letters from Nepal and Russia. While I also photograph landscapes, wildlife, and a variety of other things, the documentary style is closest to my heart.

I know my interest in people must have come from my father. Dub Wright, as he was nicknamed, had a knack for meeting people and a deep respect for their lives, without regard for their station in life. As I followed him in business, the values that he passed along served me well, and I attribute much of my success as a businessman to his example.

While my father gave me an appreciation of people and a concern for the details of their lives, it was my mother, Lillian, who first taught me about the natural world. She brought me abandoned birds' nests and

shells, and she talked to me about respect for nature and love for God's creatures. She allowed me to have pets—lots of pets—from skunks and snakes to dogs and chickens, and we raised horned toads and orphaned birds. She also introduced me to photography, and I took my first pictures when I was about twelve with her fold-up Kodak.

During my high school days, friends and I sometimes camped out along Elm Creek on one friend's family ranch. We fancied ourselves explorers and delighted in trying to find a place where no one else had ever been, a place where our footsteps were the first. We added to our bird lists and fossil collections and photographed the lizards and snakes we found. We developed a taste for adventure, and within the limitations of our youth, we traveled and explored much of western Texas.

In 1982, I attended the last Ansel Adams workshop held at Yosemite, and my technical skills improved substantially. Success in business afforded me the opportunity to travel extensively and experience many different cultures, and the faces I encountered through my travels haunted me. The wrinkles, the tears of pain and joy, the postures of triumph—I was compelled to preserve these images through my photographs.

I found the skills of interacting with people that were critical to business success also served me well in photographing the people I met, who became as interesting to photograph as landscapes and animals.

Like a climber seeing beyond the top of a mountain, I discovered new territory to encounter and to understand. I wanted to learn how people lived as much as to explore where they lived. I wanted to go as a traveler rather than a tourist. I wanted to walk through villages alone or with a small group of like-minded friends, not ride in a bus with dozens of tourists shooting their video cameras. I also wanted to visually document the good I found in people's lives around the world.

I aspire to be among the photographers who celebrate the human condition. While not denying that the world is beset with war, disease, hatred, and evil, I choose to focus on the qualities in people that seem to me to be underrepresented by today's documentary photographers: strength, joy, love, courage, determination. As I have traveled and photographed, I have seen these qualities in abundance. I have seen them in places where I myself might have given up or quit because the challenge was so great.

I believe in people—their drives, ambitions, and emotions. I see within them the unique and the universal. I am convinced that even in the most desperate of circumstances, people have the ability to know joy and to call upon their innermost selves and exhibit strengths they did not know they had. People can laugh, at others and at themselves. People laugh with happiness, and people laugh at the impossibility of their situation.

My photographic journey has been on a two-way street. I have been the beneficiary of generosity and moral uplift from what I considered to be the most unlikely of places. As I photographed, I learned the most not from teachers but from people living their lives as best they could in poverty and in plenitude.

One of the most important lessons I learned was from a photographer at the tip of South America. The trip to Tierra del Fuego was the second for my friend Bob and me. The first time, we were on our way to Antarctica. This time, we brought our wives to share the experience of the majestic snow-covered tail-end of the Andes and the Beagle Channel with its bird life and sea lions.

At the end of the first trip, two years before, Bob had left for Texas while I remained behind to photograph the beautiful Parque Nacional, situated at the junction of Chile, Argentina, and the Beagle Channel. That night I received a frantic call from Buenos Aires. Wanting to hand-carry his film through the X-ray machine, Bob had kept it separate. Unfortunately, he had left all thirty-six rolls of Kodachrome on the bus to the airport. Bob had lost all his film from ten days of photographing Antarctica.

Early the next morning, I stopped by the bus station with María Laura Borla, the very helpful director of the visitors' center in Ushuaia. The people there promised to search the buses and query the drivers. Two

days later, as I was preparing to return home myself, I found out they had been unsuccessful. Bob's film was gone.

The trip with our wives promised to be better. We had already enjoyed a cruise on the Beagle Channel to photograph the wildlife. Our skipper, Héctor Elías Monsaive, a ruggedly handsome photographer, professional diver, and charter-boat owner with piercing blue eyes, took us to the best of places. We hiked across deserted islands and saw the southern sea lions as they fearlessly pondered our intrusions. We ate giant crab freshly pulled from the sea.

The following day, we visited Estancia Harberton, the historic ranch built by the first permanent European settler, missionary Thomas Bridges. We shunned the guided tour and photographed, enjoying the cool, cloudless day. We wandered through the historic buildings, admiring the bleached bones of whales and the stuffed condors that peered from their moorings in an abandoned shed.

While Bob selected some picture postcards in the small tea room the present owners maintained for tourists, he told the vivacious young woman who served him (herself a descendant of Thomas Bridges) of his misfortune with the thirty-six rolls of film. "I know who has them," she said. "Call Mingo Galussio in Ushuaia. Someone gave the film to him because he is a photographer!"

We rushed back to Ushuaia along the unpaved bumpy road and immediately called Mingo. Not only did he have the film, but we could pick it up that evening! Bob could scarcely contain himself. He fidgeted. He recalled the views he had photographed. He picked at his supper in the quaint French restaurant as he pondered the miraculous recovery of his film.

Bob and I took a cab in a light rain that had begun to fall. We found the modest house on the darkened street, the bluish glow of a television set showing through the draped window. Bob knocked on the door. Mingo appeared. "Yes," he said, "you are the one." He withdrew a photograph of Bob leaning against the rail of our boat in Antarctica. He had developed one roll to see what it contained, and there was a picture I had made of Bob with his own camera. "I recognize you from the photograph."

We sat in Mingo's tiny kitchen and shared snacks while his wife and sick daughter watched a program on their ancient television in the corner of their small front room. He told us how he came by the film and that he had saved it because he knew it was valuable to someone who likely would claim it someday.

We thanked him and prepared to leave. Mingo spoke in a quiet voice. "Now that I have done something for you, I would like to ask a favor." We were both on the defensive. Bob had already given him the sub-

stantial reward he had advertised. What would this Argentine man at the bottom of the continent want of us? I thought it might be to take a package to a friend in the States. Drugs? Did he want us to get him a visa? My imagination ran wild.

Bob replied, "We will help you if we can. What would you like us to do?"

Mingo said, "When you find another human being who needs help, do all you can for them," he said. "That's what makes the world a better place."

Shocked, and surprised at the request, we agreed. We shook hands and Mingo led us out of the small kitchen and to the front door. Silently, Bob and I walked out into the drizzly night. How ashamed I was of my suspicions. Was I being a typical American—suspicious of all "foreigners"?

As we boarded our flight to Texas the next day, I was still thinking of this powerful experience and the valuable lesson I had learned.

Perhaps my most deeply felt experience of all was one of my first. It was during my first trip to Nepal. Some Outward Bound friends and I had compressed what would normally be a twenty-six-day expedition around the great Annapurna range into a sixteen-day marathon. After the third day, I was ready to give up. Exhausted, discouraged, and trailing the rest of our group, I wondered how I had ever had the misfortune to

commit to such a project. As I struggled up the trail, I met a Nepalese man coming down, carrying on his back an enormous basket of oranges. I stood aside from the narrow trail to let him pass. He stopped before me, and handed me an orange.

I reached into my pocket to pay, but he waved away my hand. "Nameste," he said, meaning "I salute the god within you!" Then he smiled and walked on down the trail. I never saw him again. Before that meeting, as I walked through the villages along the trail that were smothered in poverty, I had felt so superior to these folks. As I watched my anonymous friend walk down the trail with his heavy load, I realized that though I am privileged, I am hardly superior. His simple act of generosity placed him with the angels.

Over the years, I have met many men and women who opened their hearts to me. I cannot tell you why, but I know that I am the one blessed. While I set out to learn about the world that lay so interestingly before me, I have come home knowing more about myself.

I met Joseph while photographing Tanzania in 1985. Joseph served as a guide who assisted me while I was there. Black and poor, burnt by the sun, and wizened by work and many years without enough food, Joseph remained a man proud of himself and his country. He took the most pride in the majesty and rarity of the animals that inhabited this

land. Because he could not afford a field manual for the birds and animals, on my return to the United States, I sent him one. I later received this reply: "Mr. Bill, . . . please remember that we can only secure the peace in the world we all passionately yearn for, by serving others. May you justify our hopes and rise to the top . . . and not forget us when you get there."

As I read Joseph's letter, I believe I understood what he was saying. Joseph had seen many Americans and people from developed countries of the world as they traveled to his country to learn about and photograph the African animals. He could not help but contrast the lives we led to the basic existence of most Africans. I took Joseph to mean that those of us from developed countries had a greater responsibility to secure peace among all peoples, and his letter was a plea to not forget those in need as our own countries became wealthier. It was also a plea to us as individuals to do what we can in the world as we gain positions of influence in our own countries.

I will never forget Joseph, or the thousands of "Josephs" I have photographed in my personal journey to understand other people's lives. These images form my tribute to those who, despite the often terrible conditions of their daily existence, remain proud and generous, living with a sense of purpose and capable of joy and hope.

Bill Wright, *Abilene, Texas*

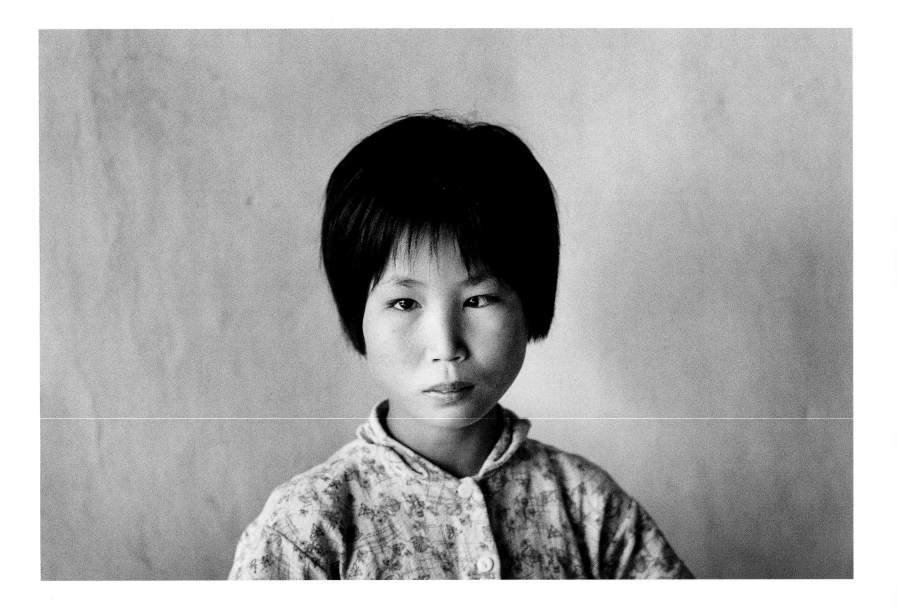

Introduction by Sam Abell

A photograph by Bill Wright hangs on the wall above my writing desk. It is at eye level, and I meet the gaze of the young Chinese woman directly. I see her as Bill saw her, evenly, respectfully. Seeing her portrait stills my mind. I think of her life. I think of Bill and the path of his life that led him to her. I think, too, of the mystery of beauty and of the power of photography and of the place it has in people's lives.

It is at the junction of these thoughts that Bill Wright lives his life, does his work, and creates his art. This book is a testament to his well-lived life and a tribute to his achievements as a photographer.

I first met Bill seven years ago at a workshop in Santa Fe. It seems, however, that I have known him much longer. Bill creates this sense because of the uncommon power of his personality. "Wright World" is the name of his website, and it is altogether fitting because Bill has created of his life a rich and compelling world into which others are drawn. They are attracted by Bill's enthusiastic and direct belief in them and their world.

Proof of this is in Bill's photographs. The people he is meeting are taken up with this man who is so taken with them. We sense them meeting Bill, being with him, being drawn into his life. It has happened to me, I have seen it happen to others, and I repeatedly sense it happening in the photographs of this book.

That is because the photographs themselves are strong. Bill's attraction to individuals is based on their strength of character, and he wants, above all, for us to feel this in his photographs.

Thus his photographic technique is direct. The foundation of Bill's photography is his decision to work in black and white. This choice places his work in the context of classical photographic portraiture. Moreover, for us, it eliminates color as a consideration. We are allowed to concentrate on the setting and the character of the people within it.

These people are presented in two vivid ways. First they are shown as Bill encounters them—as they are—in their own settings. There are many ways to go about portraiture, the most familiar being the studio portrait where the photographer controls every aspect of the situation— from choice of background to lighting and styling. A few of Bill's portraits, including the young Chinese woman, suggest this tradition, but in fact they are "found" photographs, not styled into existence in a studio.

The worth of this approach is comprehensive and affects the subject, the photographer, and the viewer. For the individuals being photographed there is the comfort of being seen in their own setting, surrounded by the world of their own creation.

For the photographer there is the unfolding adventure of entering the dynamic world of humanity and photographic opportunity. There is also the challenge of coping with ever-changing elements of light, setting, and mood. This style of photography, with its emphasis on intimacy and spontaneity, is ideally suited to Bill. It brings out the best in him—as a person and as a photographer.

For us, the viewers, Bill's documentary approach means we have a thought-provoking view of not only people but people's lives. Bill's photographs reveal a richness of surrounding detail even in the most modest of circumstances, and through this we are asked to reckon with more than individuality. It seems that Bill's portraits ask us to consider people's history and destiny as well as the portrait moment pictured.

The other noteworthy aspect of Bill's photographic technique that affects his finished work, and therefore us, is directness. In only a few of his portraits is the individual shown in an "off-camera" moment. Almost always Bill chooses to portray the people he photographs in the most dignified manner: gazing directly into his camera. Bill succeeds with people and with portraiture because he creates a partnership with the people he photographs. This dignifies the act of photography. Dignity, in fact, is the hallmark of Bill's work. Drawing dignity from situations is, I believe, a natural and very nuanced act for Bill because he himself is conveying respect to the people he meets.

Though dignity and respect are the basis for Bill's dealings with people, and therefore are primary constituents of his portraits, they are not the only attributes that influence his relationships with people or shape his work.

Bill has a keen and contagious curiosity. He is genuinely interested in people's lives. He'd be there for them whether he was a photographer or not. But the momentum of his own curiosity carries him forward into situations—into lives—and he then makes photographs within his encounters.

Above all these attributes is one characteristic that more than any other shapes Bill's life, his work, and this book. That is his generosity of spirit.

In the workshop where we met, an appeal is made at the outset of the week. It is a call for participants to be generous—generous with their knowledge, with their time, and, above all, to be generous in spirit. In the many workshops where that call has gone out, no one has more truly answered it than Bill.

For the past six years Bill has returned to the workshop to sit in, to listen, to speak, and to see new work. He looks at work with the eye of a curator and with the goal of giving deserving, emerging photographers exhibits of their own. More than a dozen such gallery exhibits have been mounted by Bill. Because of this, when I think of people's lives being lifted up and bettered, I think of Bill Wright. There can be

only one conclusion about Bill's generosity: It is a natural act based on the belief that bettering people's lives is a good thing and that being generous is the way to make that happen. The remarkable thing is to see how contagious his generosity is. I know that as long as Bill is present, selfishness will not be allowed to exist. By itself that is a priceless gift to others.

Another inspiration to us is Bill's example of reinventing his life to accomplish artistic goals. For thirty years Bill worked and succeeded as a businessman. But the call of photography persisted, and in his fifties he conscientiously turned over active interest in his business to his employees and struck out as a full-time photographer.

In the ensuing ten years Bill has photographed, written, and produced three esteemed books, two on native American tribes living in Texas and another, *Portraits from the Desert: Bill Wright's Big Bend,* on his lifelong interest in the unique landscape and life along the Rio Grande as it makes its dramatic cut and turn through the remote border country of southwest Texas.

Bill also undertook a steady schedule of ambitious travel beyond Texas and Mexico. It was "down-on-the-ground" travel—not tourism. Meeting people drives Bill, not seeing sights. Photography and, in particular, the dream of this book have given high purpose to those travels.

From the first time we spoke Bill has held forth on the promise of this project. And, from the start, this body of work has been called *People's Lives.* The title—like the dream that inspired it and the work that fills it—has lasted.

The book's title is so suggestive of stories and storytelling that it would be a shame if Bill—a natural storyteller—didn't relate in writing some of the most special stories that accompany his photography. He has done so. It is a shame, however, that readers won't hear these stories in Bill's distinctive and disarming voice, which rises from his Texas roots and freely flows no matter how far he is from home.

Taken altogether, Bill's work is reminiscent of the most influential photography book ever published, *The Family of Man.* This landmark book and exhibition, first shown in New York's Museum of Modern Art in the early fifties, rose from the era of optimism that enveloped America following the Second World War. It was an era that saw the creation of the United Nations and the emergence of the United States as the most influential nation on earth. It was an influential time in the life of Bill Wright as well, coinciding with the beginning of his own independent travel and his first photography.

As I consider Bill's collected work today, that atmosphere of optimism returns. The belief in brotherhood and in the betterment of people's

lives that underlies the principles of the U.N. and *The Family of Man* also inspires Bill's photography.

There are consequences to the way that Bill lives and works. Just one of those consequences affects me every day. Because of him I have a significant connection with someone I have never met. She is the young Chinese woman gazing steadily at me from the wall above my desk. I wrote that her portrait makes me think of the mystery of beauty. Her expression asks a question I cannot answer. Because of that I return to her.

In the finest of photographs there is something unknowable, something unmemorizable that holds us. Such photographs are gifts. In this book Bill Wright gives them to us.

People's Lives

A Photographic Celebration of the Human Spirit

In 1983, my wife, Alice, and I traveled to China to assist in the development of a wildlife sanctuary for Red-crowned Cranes in the Heilongjiang Province. The Chinese scientists who supported the mission became friends, and the laborers building the facilities that would become an interpretation center were shy but willing to be photographed. This man's companions were giving him friendly taunts while I made his portrait.

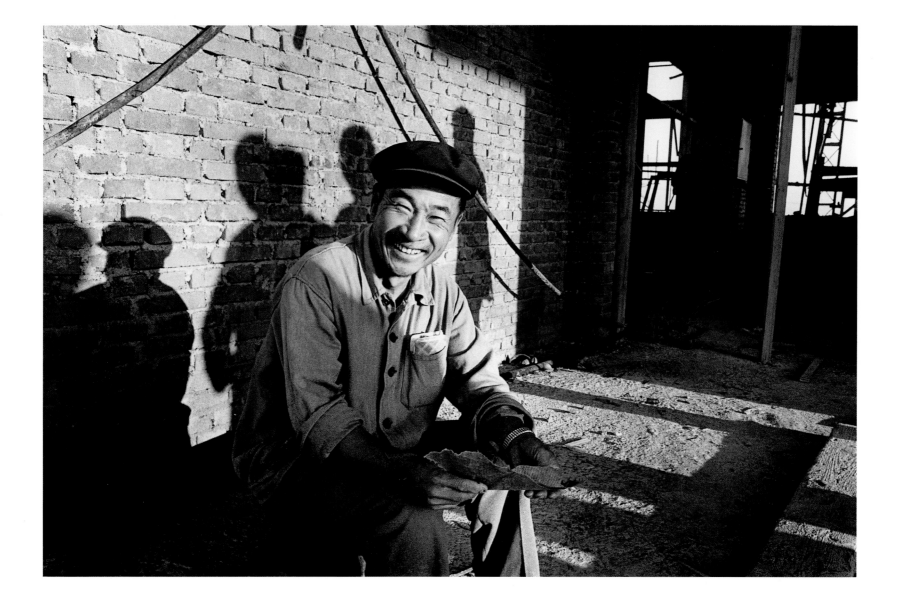

My daughter, Alison, and I set out to climb Mt. Kilimanjaro in Tanzania in 1985. We spent one night on the way to the mountain near Usa village, and I wandered into the hut where this woodcarver was working. I admired his craft and asked if I could take his picture. He refused. I pleaded. "Your work is interesting," I said. "I will send you a copy when I return to the United States."

"Well, okay," he finally agreed. "Just don't be a liar."

I supposed that many tourists who had visited his small shop had photographed him and promised to send him a copy but never did. I delivered!

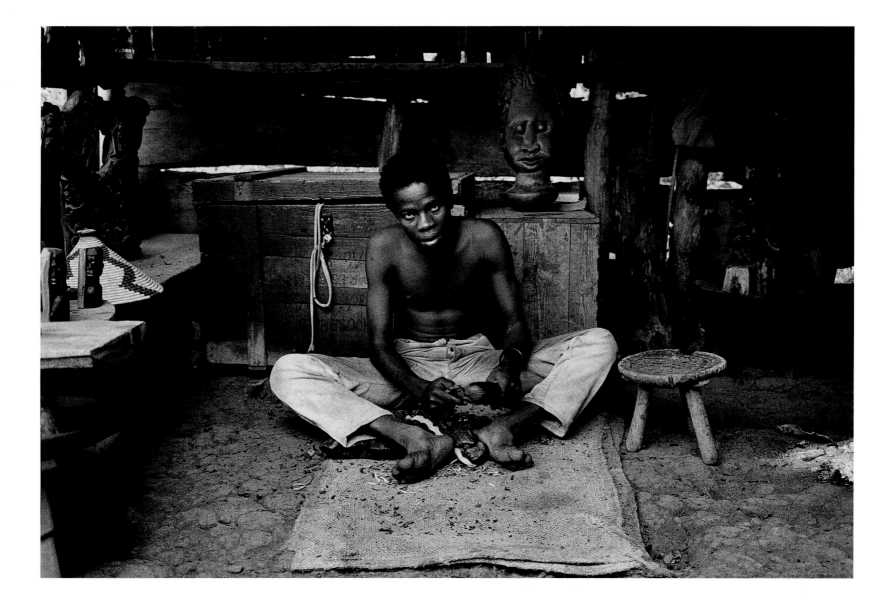

Sometimes I encounter people who are so full of life and enthusiasm it makes me feel good to be around them. They give me energy and turn any cloudy day into sunshine.

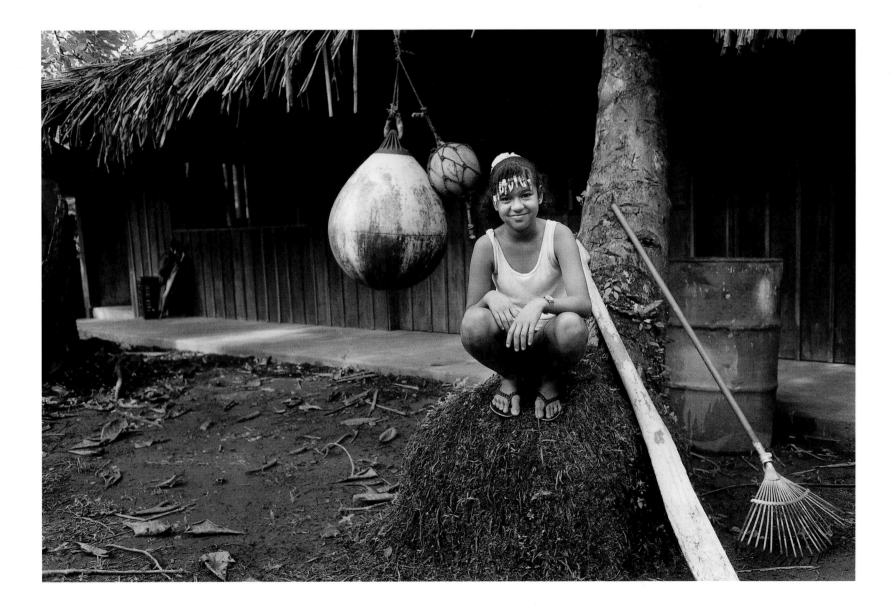

There is debate about whether photographers should pay the people they photograph as they travel the world. If it is a face or a situation that I want, I will gladly pay a small amount. I consider it a modeling fee and understand that the subjects have given me something valuable — a sense of themselves. More frequently, I will ask if they would like a copy of the image and always send one if they give me their name and address.

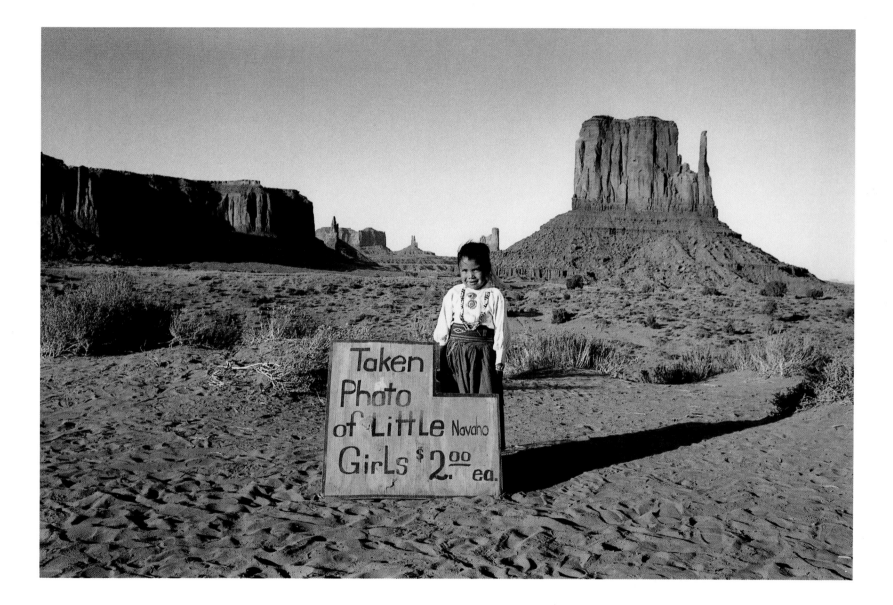

I was struck by the optimism of this man
with a shop that seemed to be in the
middle of the Sahara Desert. Actually,
there were enough travelers passing by
to support him, as his modest shop was
near a major tourist attraction.

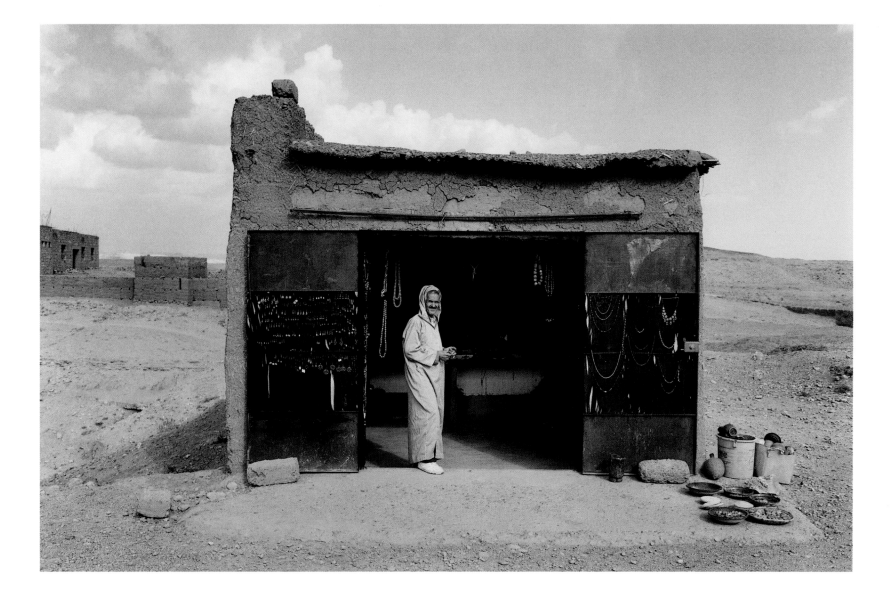

I spent a long weekend walking the streets of New York City as part of an Outward Bound urban experience with several other directors of OBEX, the Outward Bound Executive Committee. We were in town for a meeting, and the urban course was organized to give us a complementary experience to hiking in the wilds of the United States. The street people I photographed were pleasant and friendly. This young woman was walking along with such a light step; I wanted to capture her spirit in a photograph.

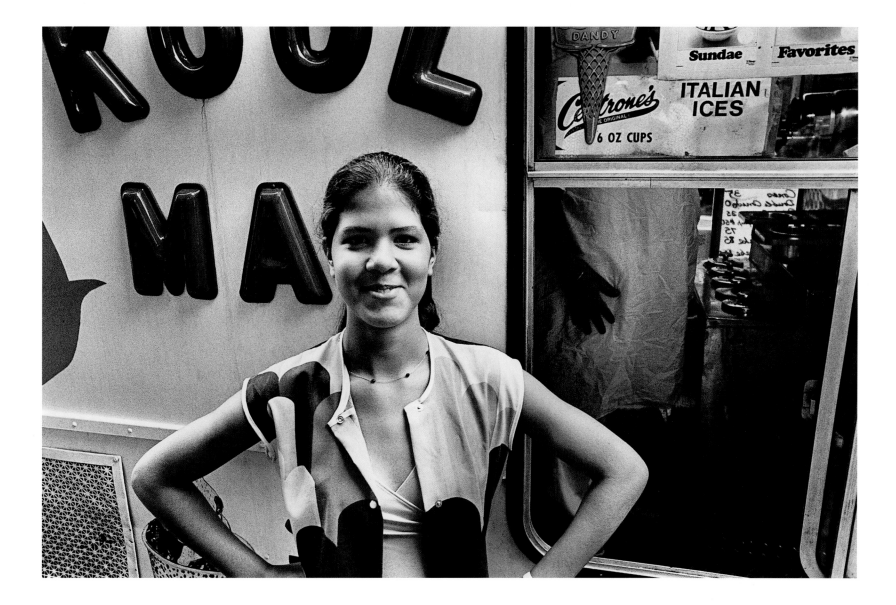

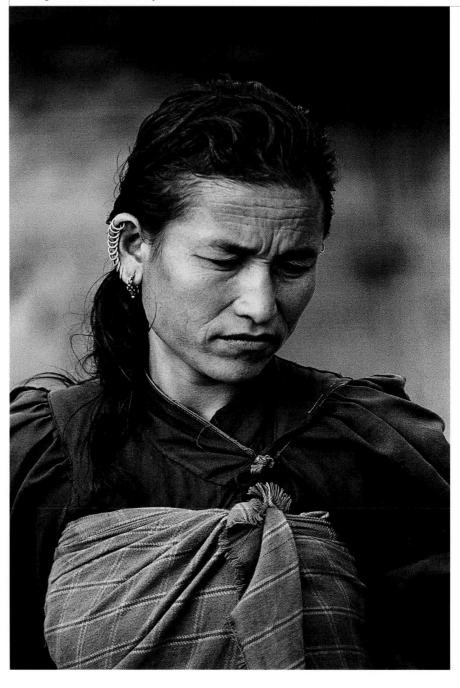

Early one morning as I was walking through a small group of dwellings alongside the trail, this Nepalese woman was entering her small home. On her back, not pictured, was her baby, wrapped tightly against the cold. Life in these small remote villages is difficult, but, still, the people greeted me with smiles of welcome. After I took her photograph, the woman invited me into her house to share a cup of tea with her family. She told me she had to walk an hour for wood for the cooking fire because the locally available supplies had been consumed. Wood was their only fuel.

Children in Nepal were
curious and outgoing. It
was a cold day, and this
girl was shy and tried to
talk with me in English.
Verbal communication
is often a failure, but
with hand signals and
laughter, I believe a
person can communicate
anywhere in the world.

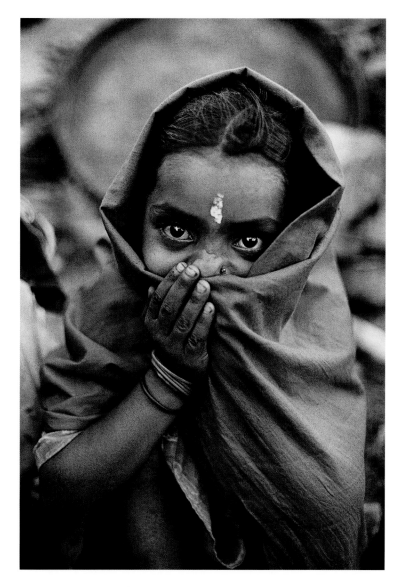

Khadra was the grandmother of my friend, Texas poet Naomi Shihab Nye of San Antonio. When Alice and I visited her home in Palestine, she lived with son Itzat Shihab, the mayor of the village. She was almost 100 years old. Naomi had notified them of our visit, and they greeted us with great hospitality even though it must have been inconvenient, as they were celebrating Ramadan. Khadra was pleased that we had made the effort to drive to her village and asked us to tell her granddaughter that she was well. After I photographed Khadra in the garden, Itzat took us on a tour of the village and introduced us to his friends we met along the way. I asked him to describe his most difficult task as mayor. He told me that the worst thing that had happened in his small village was when Israeli soldiers pounded on his door at night and demanded that he lead them to the house of one of the village's inhabitants. Because it was a time of Arab militancy, the taxi driver who brought us to the village was nervous, and we returned to Tel Aviv before nightfall.

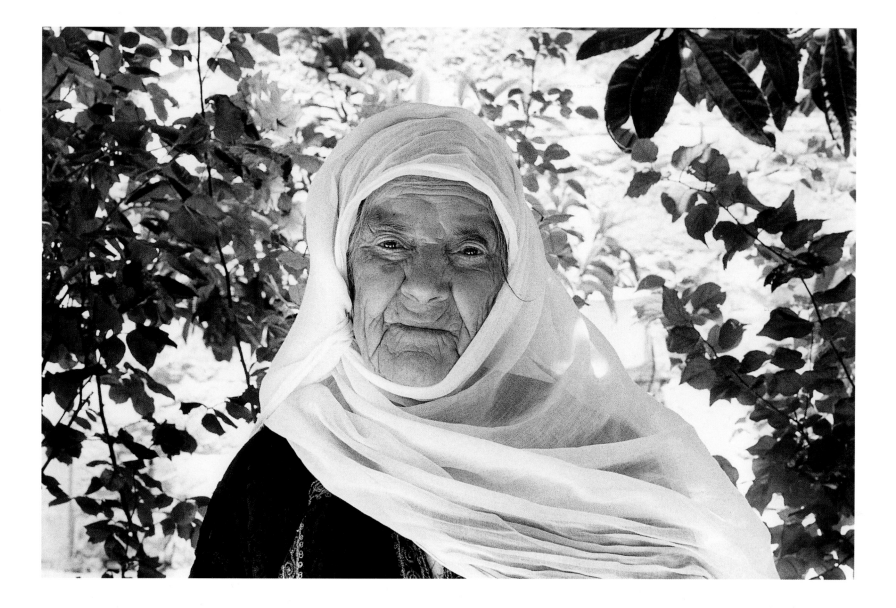

On a trip to Nepal in 1990, I visited my friend, Nima Tenzing Sherpa, who had been my *sadar,* or guide, during my earlier visit in 1978. He was delighted to see me and arranged to take me to a Buddhist temple to photograph. The temple guardian was posted at the door, and Nima secured our entrance. I value the local contacts that I have made not only for the rich experience of friendship but also because of the access to photographic opportunities they provide.

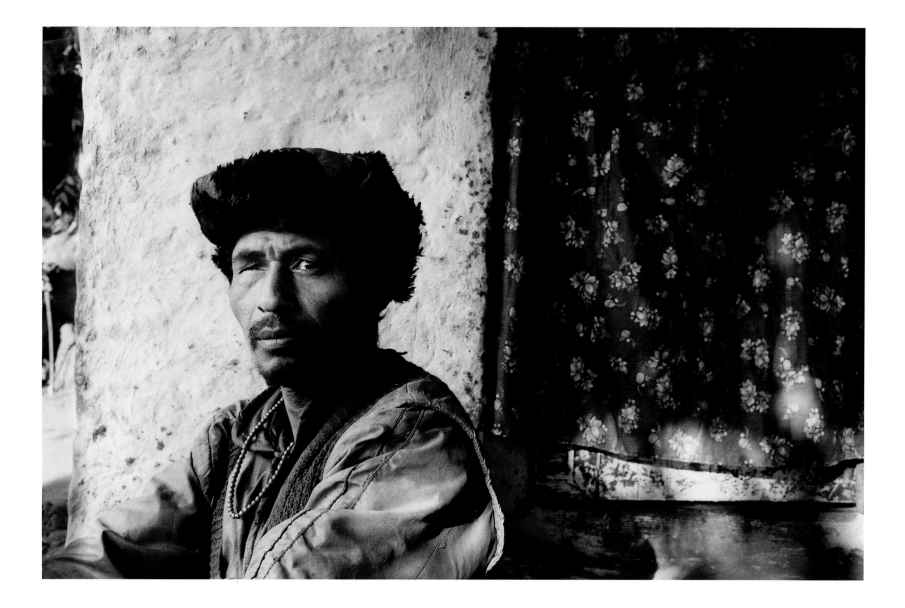

During a trip to Egypt, Alice elected to stay in Cairo while our son, Mitchell, and I flew upriver to the ruins of Luxor and Karnak. We joined a local tour group and visited the ruins, then crossed over the Nile to the Valley of the Kings and Queens. A couple of young British men attached themselves to our group over the protests of our tour leader, insulted the Egyptian guard at the entrance to one of the tombs, and made themselves generally insufferable. Our guide kept his composure and was totally professional the entire time, although the group would have preferred to call the police and lock the bums up. At the end of the tour, our guide was resting his tired feet but remained cheerful and upbeat in spite of the difficult experience with the interlopers.

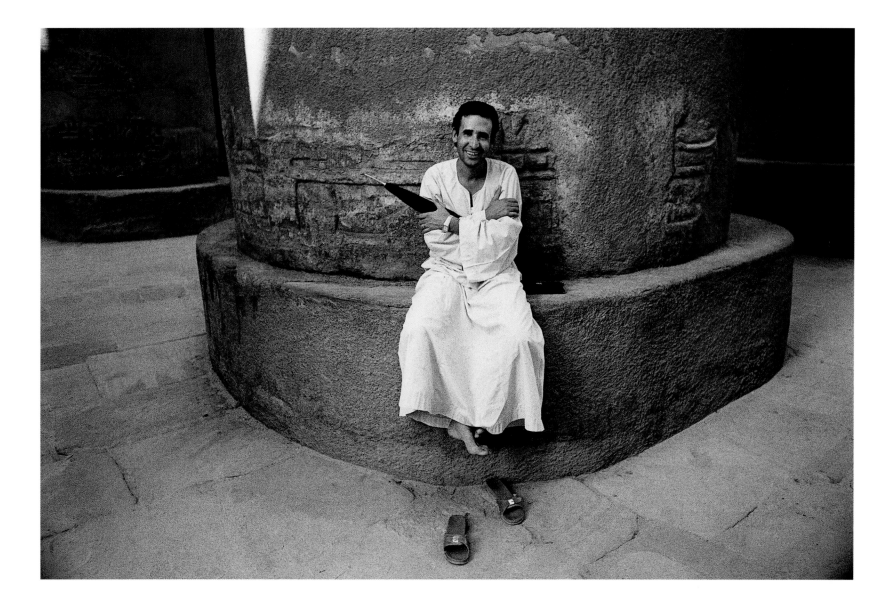

During an Earthwatch expedition to Heilongjiang Province, I wanted to photograph in the local village near the nature-preserve research station. I asked permission to visit, but the local party representative who oversaw the project continued to slow-play me. It came down to the last day that I would be in the area, and without permission I walked to the village, which was about a mile away. The people I met were delighted that I had come and vied with one another to escort me to their homes. I photographed for a couple of hours until I was missed at the research station and the supervisors came to get me. In the distance I could hear jet aircraft taking off. Perhaps they were nervous about military security.

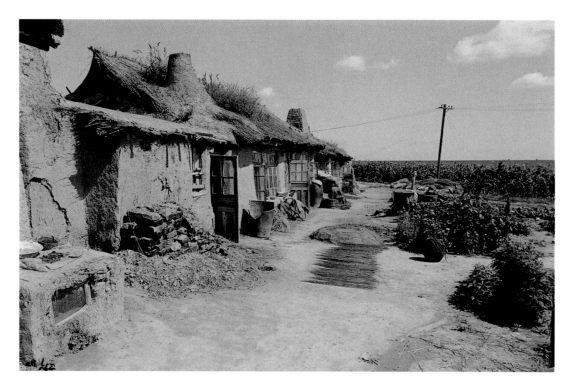

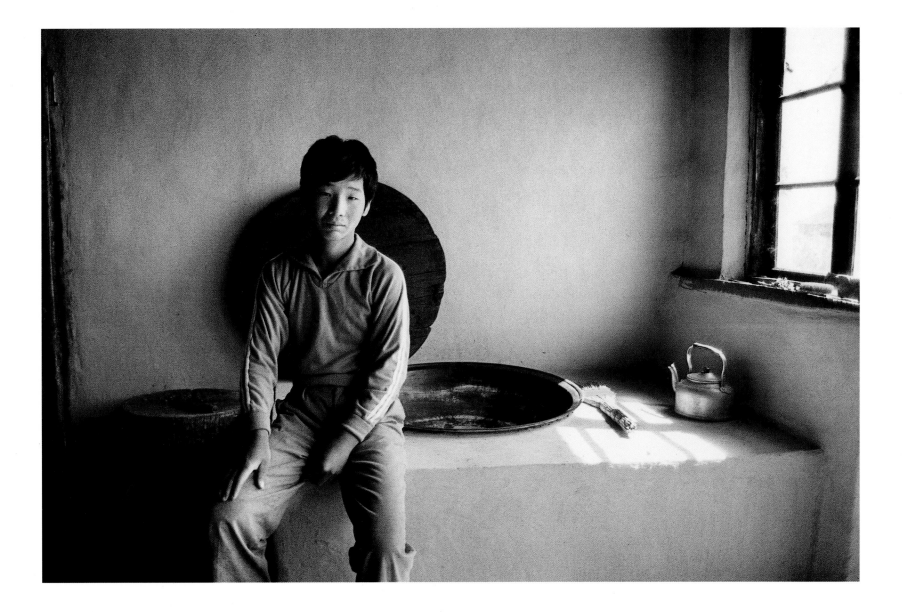

This young girl was very proud of the doll that, evidently, she had just acquired. I asked if I might photograph her with it, and she quickly agreed. I find that talking about something people have with them puts them at ease and makes it possible to make a photograph when otherwise they might be too embarrassed or shy.

Girl with Doll, Costa Rica, 1993

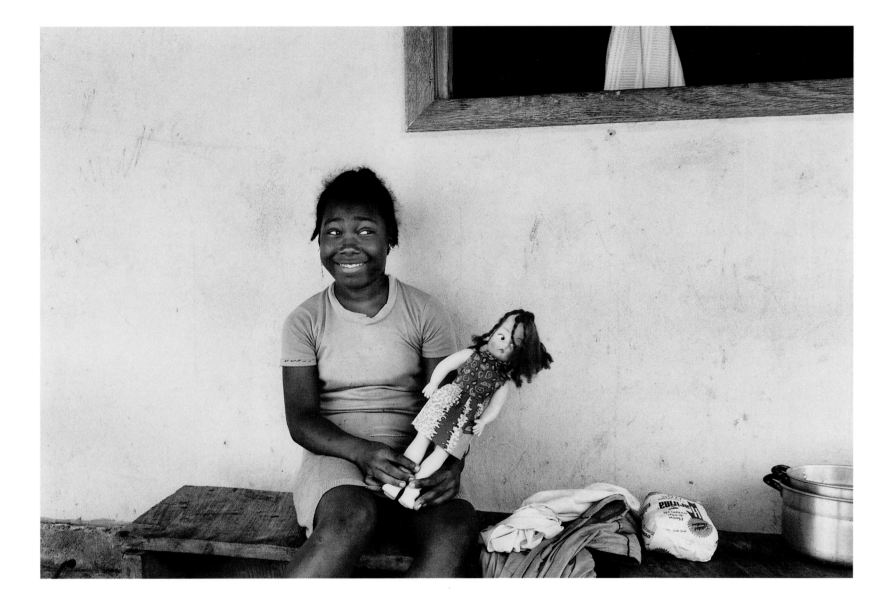

Miss Opal Hunt, Bradshaw, Texas, 1996

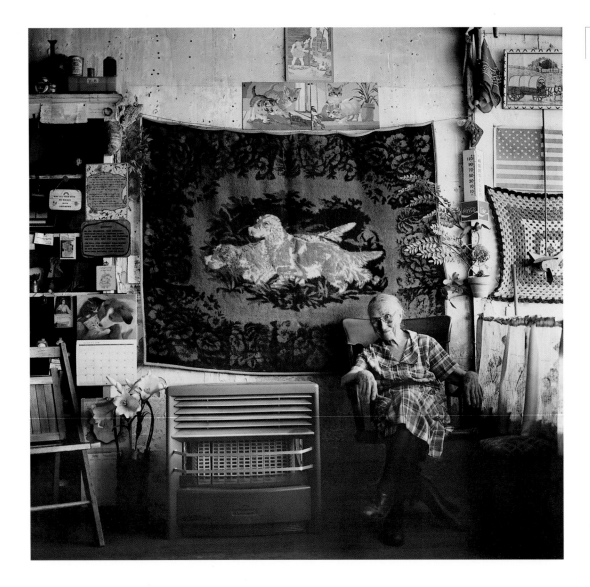

Opal Hunt lives in the small community of Bradshaw in west Texas. When her parents died many years ago, she continued to run this store. Today it is no longer a general merchandise store but still contains some of the old merchandise that has been there over 80 years. She now sells soft drinks and candy to visitors, enjoying the company. Many people stop to see what is now a living museum.

Texas cowboys bring their work inside, which makes for interesting decor. While deer hunting on a west Texas ranch, I was invited in to visit with the foreman, who lived in this house. His living room was crowded with Indian artifacts, ropes, and mineral block for the cows. Coffee-pot hospitality is normal for Texas ranch life.

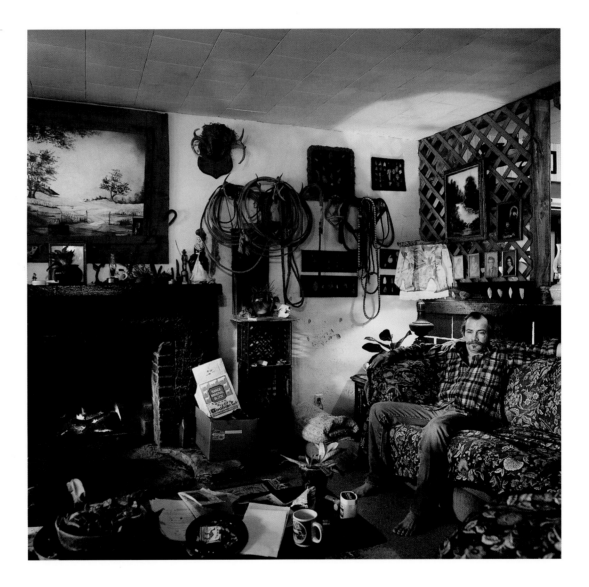

On a trip to Antarctica, I visited the Beagle Channel settlement of Puerto Williams, a Chilean naval base. This woman and her sister were said to be the last living full-blood Yahgan Indians. She made toy wooden canoes that were models of the ones her ancestors used when Charles Darwin and the Beagle crew rounded the tip of South America during their incredible voyage of discovery.

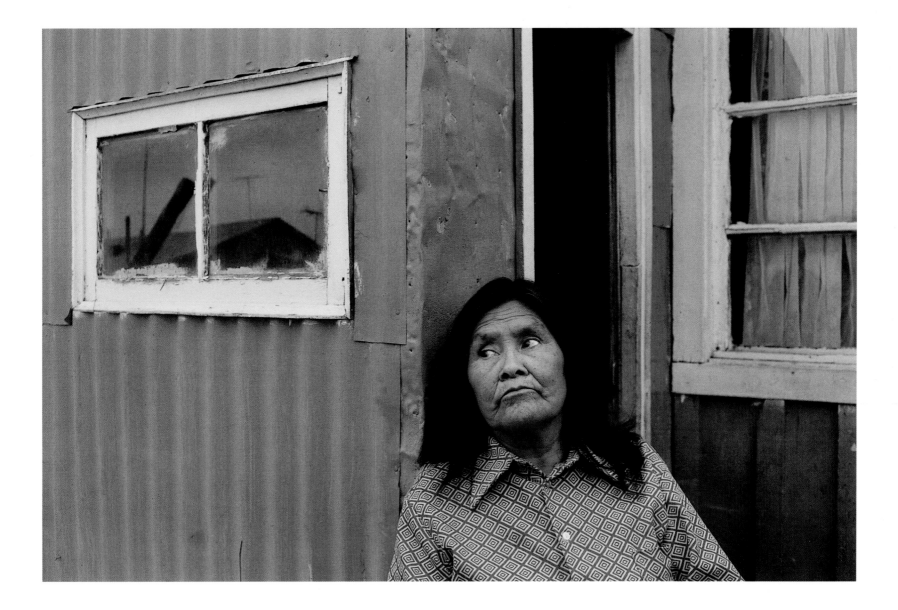

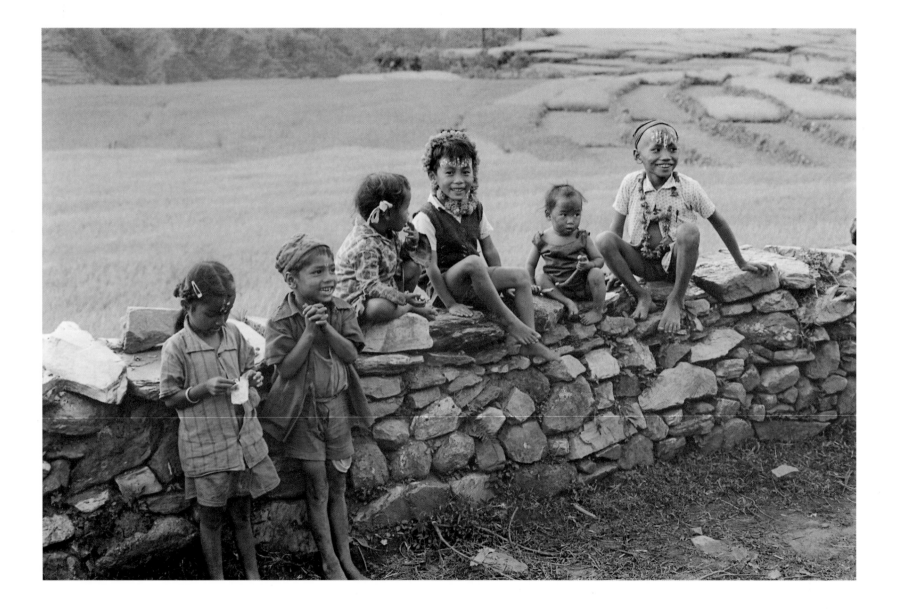

Young Religious Celebrant, Nepal, 1978

I met this young man alongside the trail and was fascinated by the markings on his face and the strings of flowers. It was the time of a festival in Nepal, and he was celebrating. I met many others along the way with similar decoration.

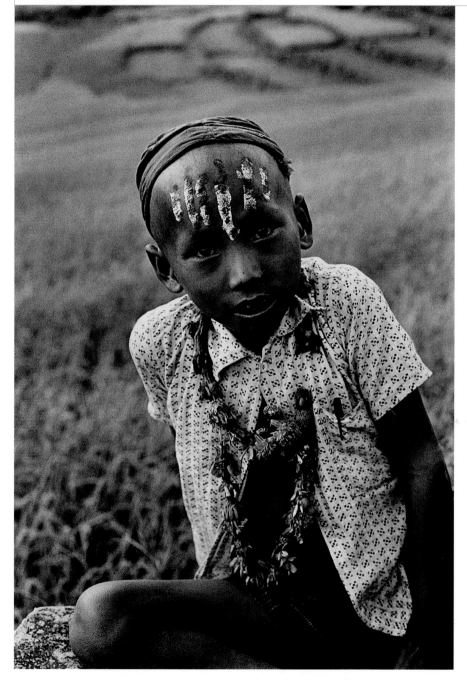

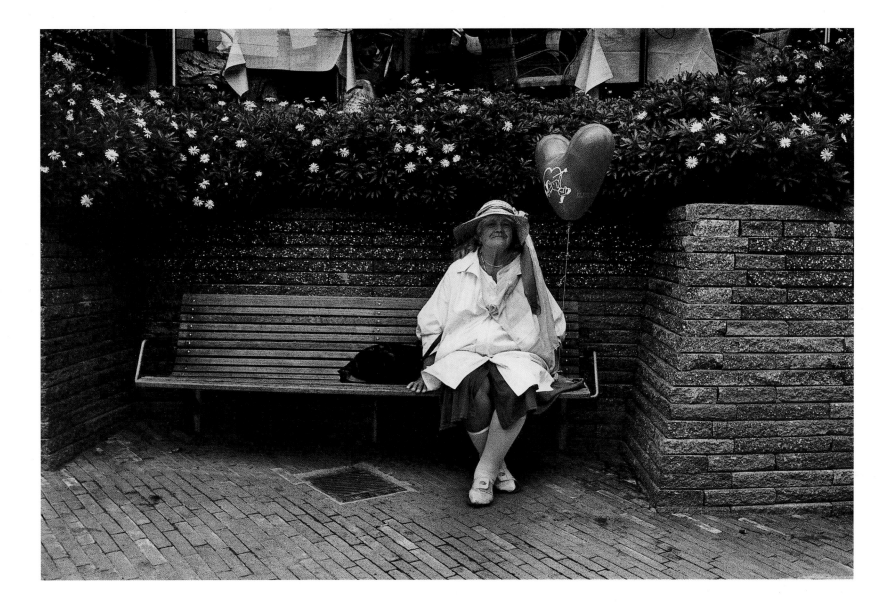

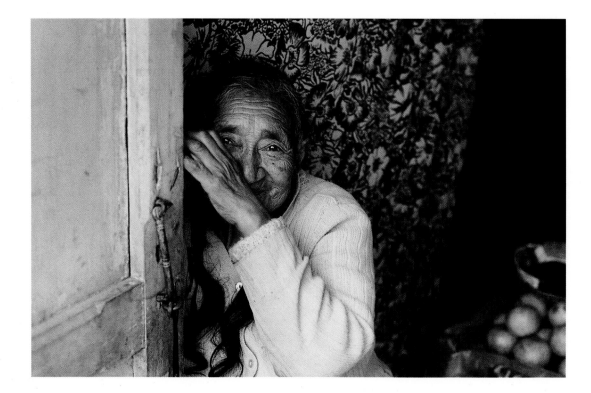

Coffee with a Friend, Abilene, Texas, 1981

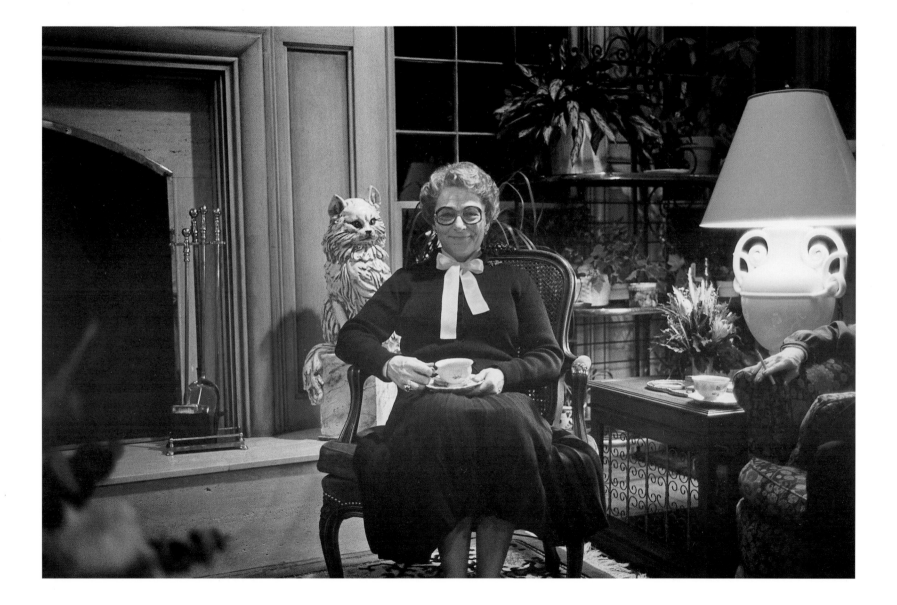

Kitty had been blind for many years when I came to her house to visit and photograph her. A friend, Robert English, had been looking after her and wanted us to meet. Robert respected the old woman for her teaching and kindness to him when he was young. She told me that she had been blind most of her life. She was pleased that I wanted to photograph her as part of the documentation of Abilene's centennial celebration. I made several photographs of her sitting in a rocking chair and then on her couch, her room illuminated by light flooding through an open window and a bare light bulb. Things she could touch and find surrounded her. She told me about her early years when she could see and about raising a family.

About five years later, she had surgery on her eyes and regained her sight. I brought her a photograph and, for the first time, she was able to see herself as a blind person. The memories of those darkened years flooded back. She said the photograph would not be a memory of the years she was blind but rather a reminder to be grateful for the light.

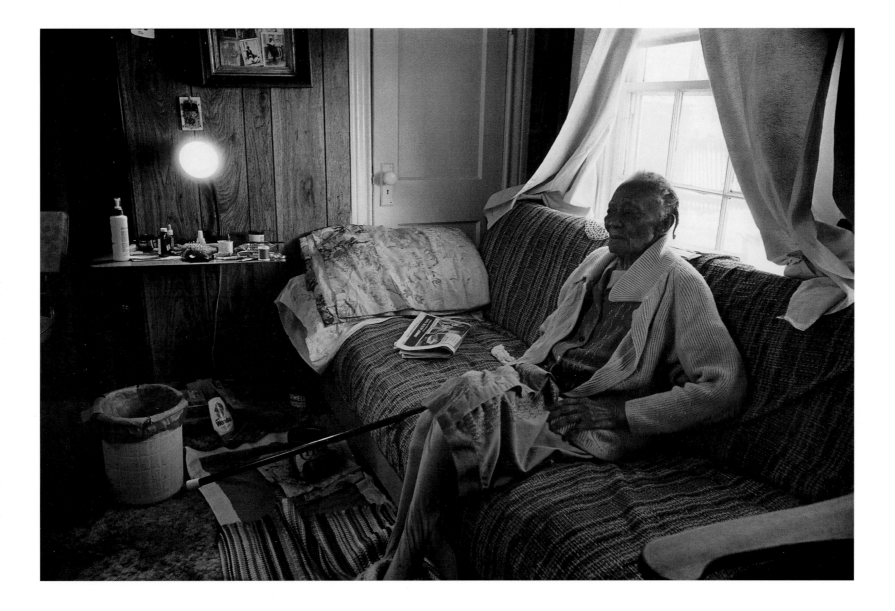

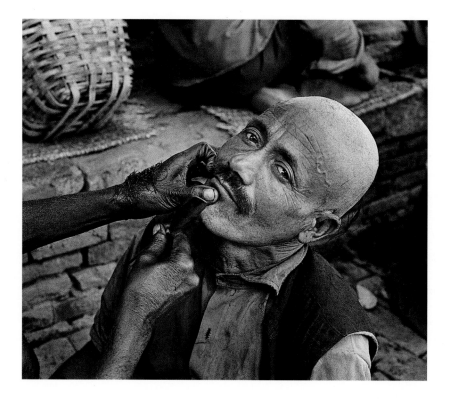

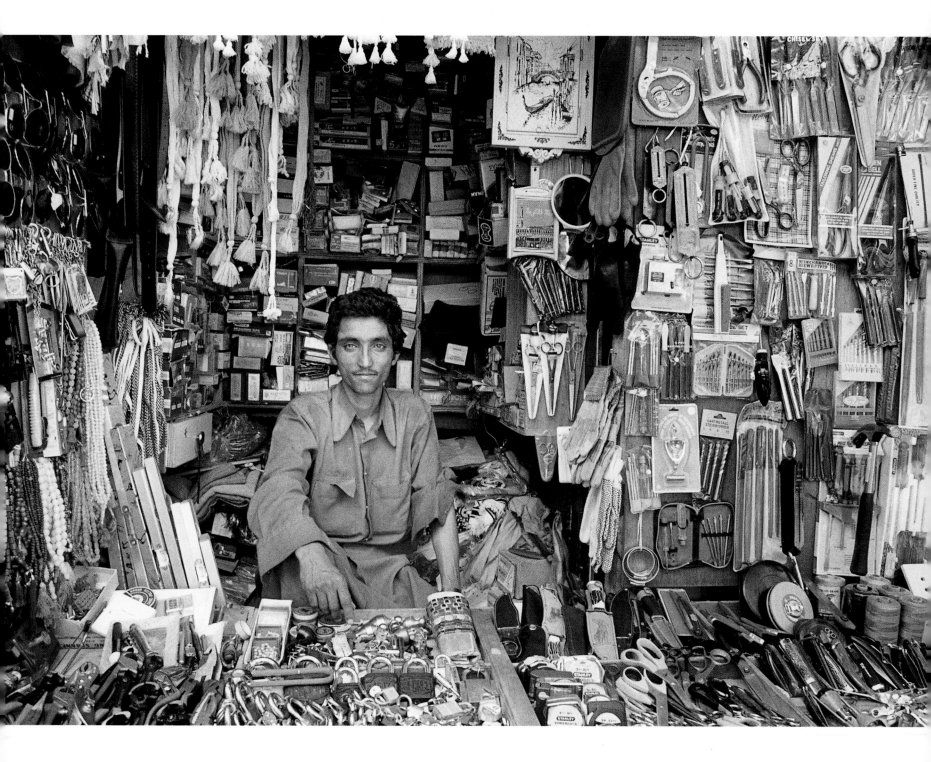

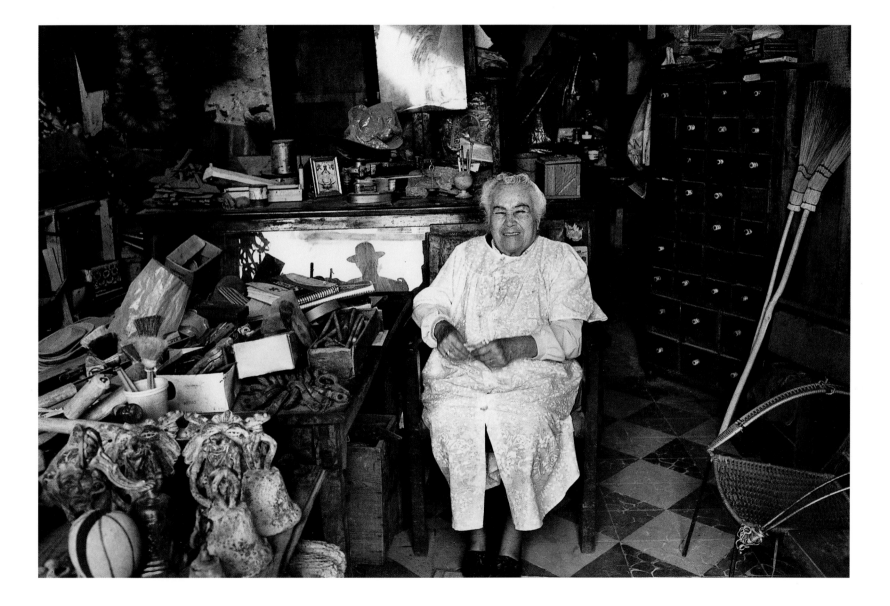

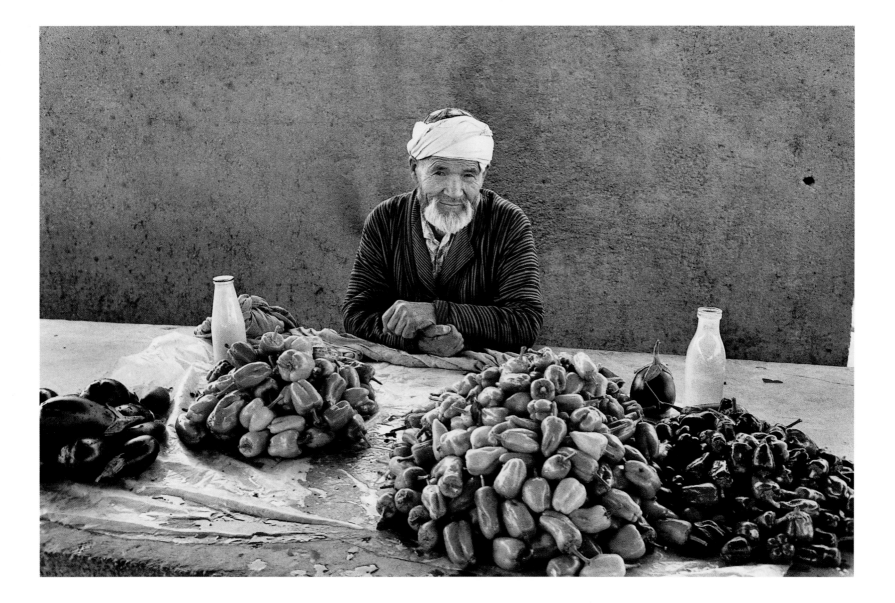

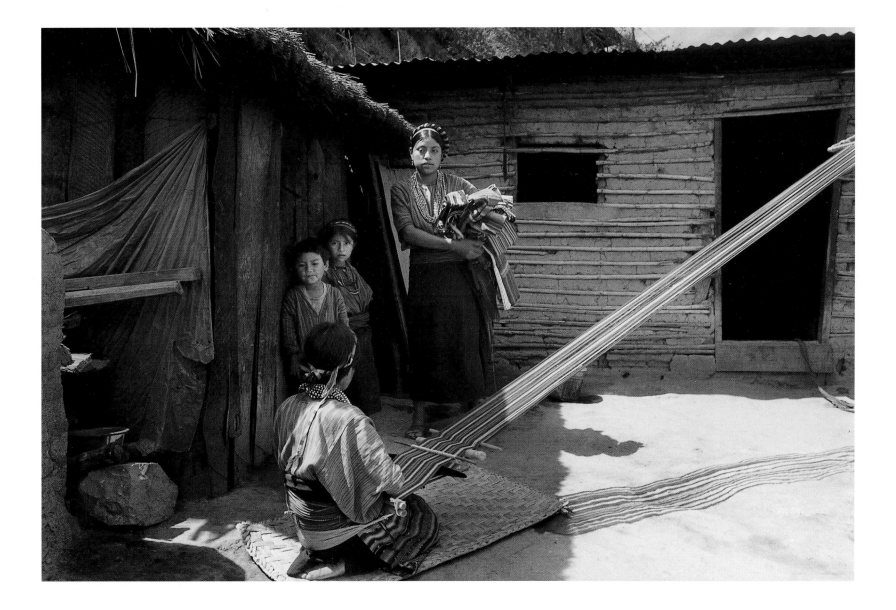

Hairdressers' Convention, Abilene, Texas, 1981

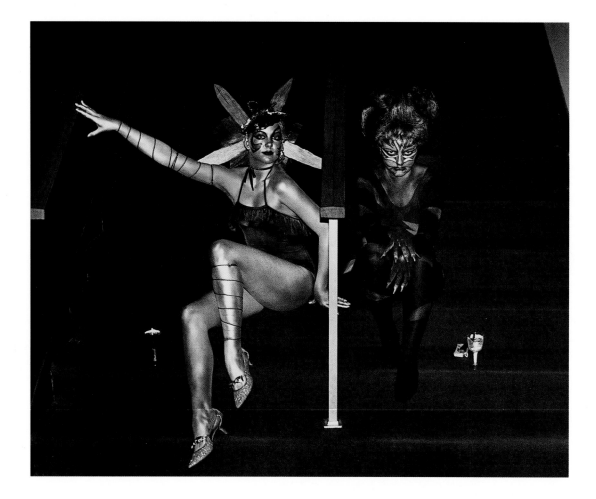

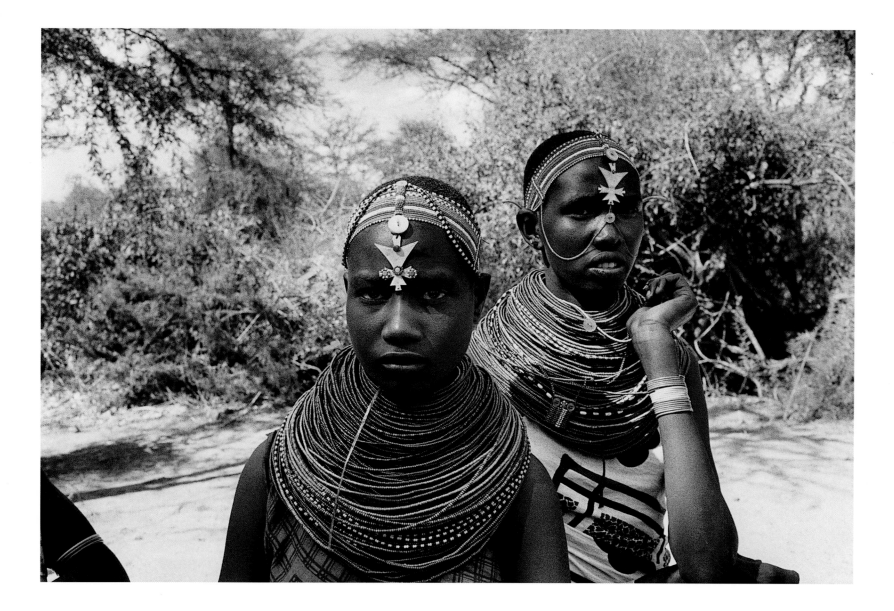

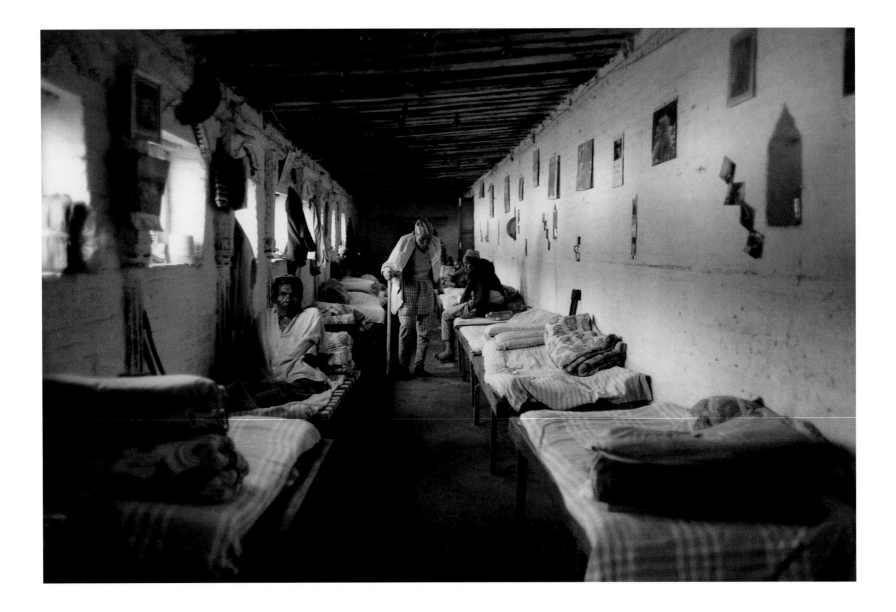

Colony Resident, Katmandu, Nepal, 1990

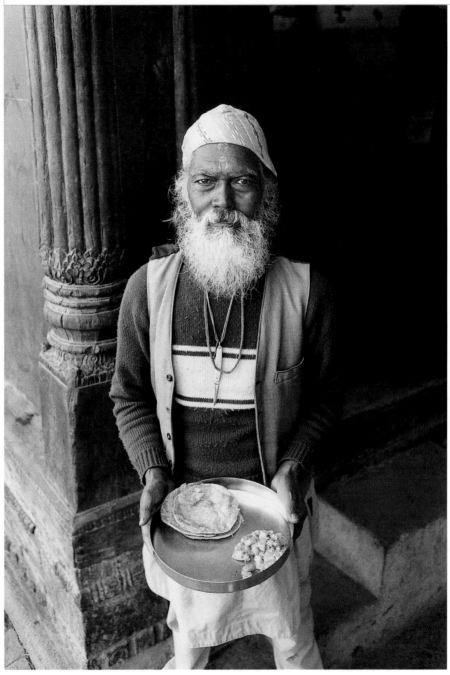

This distinguished gentleman was an inmate of the leper colony in Katmandu but was cheerful and carried himself with pride and self-respect. He posed for me with his lunch tray and thanked me for coming to visit. He spoke perfect English so that communication was not a problem, and he told me how thankful he was for a place to live with others who were similarly afflicted.

When I photograph groups of people, I find it interesting to allow them to arrange themselves in the manner they choose. The woman in the center of the aisle was the manager of the group and made sure that everything was in order and people were properly positioned before letting me make the picture.

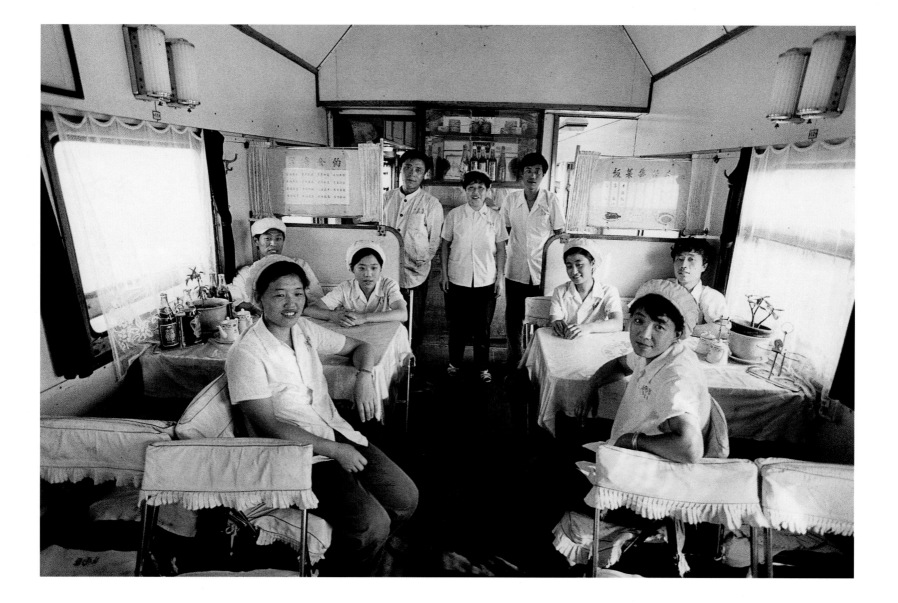

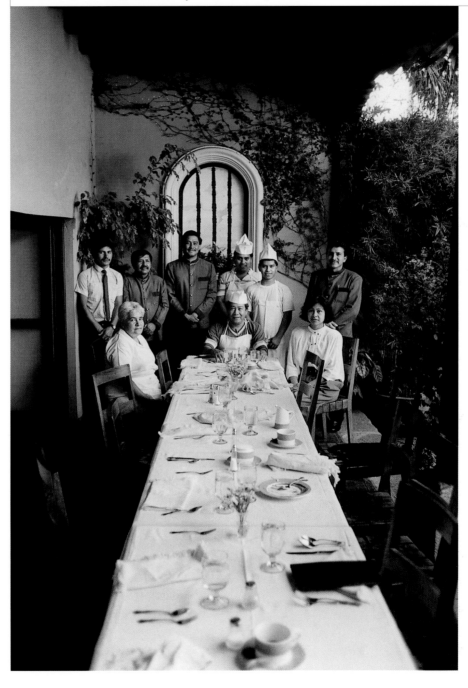

When I asked this group to arrange themselves for a photo, they gathered themselves at the end of the table on which our party had eaten. All the staff wanted in the picture!

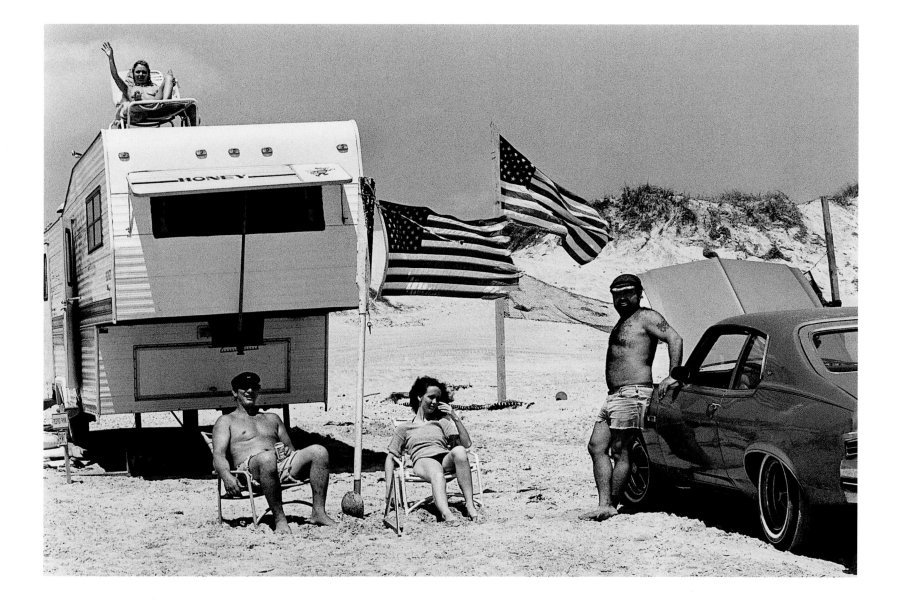

The fish *souk,* or market, in Dubai is a fascinating place with fish of every kind and shape displayed for sale. The vendors were calling for me to photograph them with their wares, and there was a lot of joking and laughing going on regarding my attempts to communicate. I often find that I can turn this language difficulty into a situation where we all laugh, and laughter is a great icebreaker.

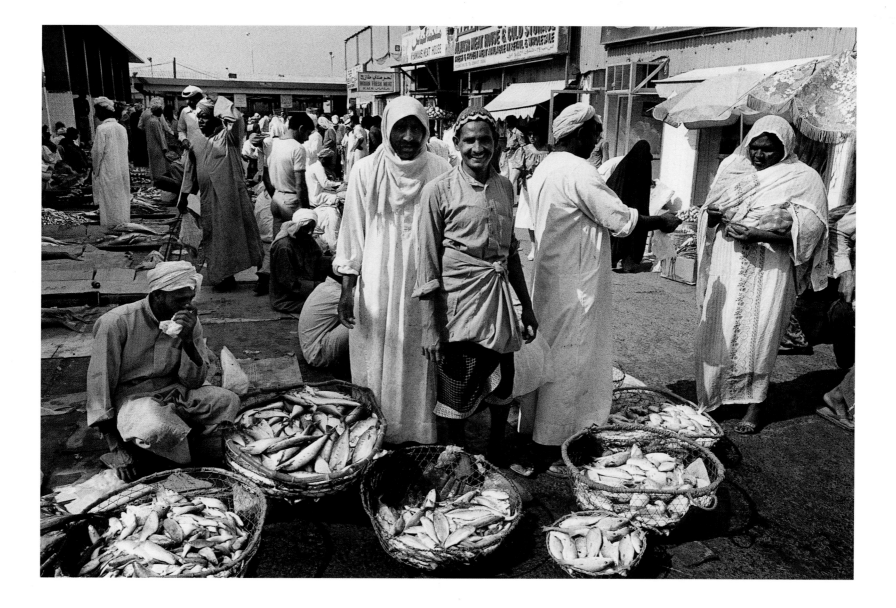

My son, Mitchell, and I encountered these men tending their sheep in the Valley of the Kings and Queens. They didn't quite know what to make of us. I tried to make them laugh with every trick in my book, but they kept their curious, solemn pose. When we moved on, they broke out laughing among themselves.

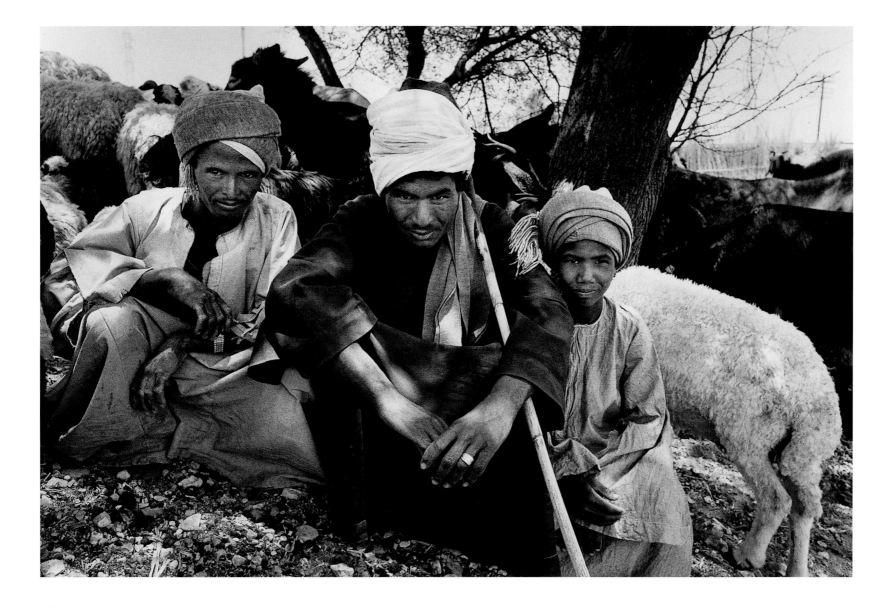

I stopped at a convenience store,
and this oil field worker and his date
parked beside me. They were going
to a party in the welding truck.

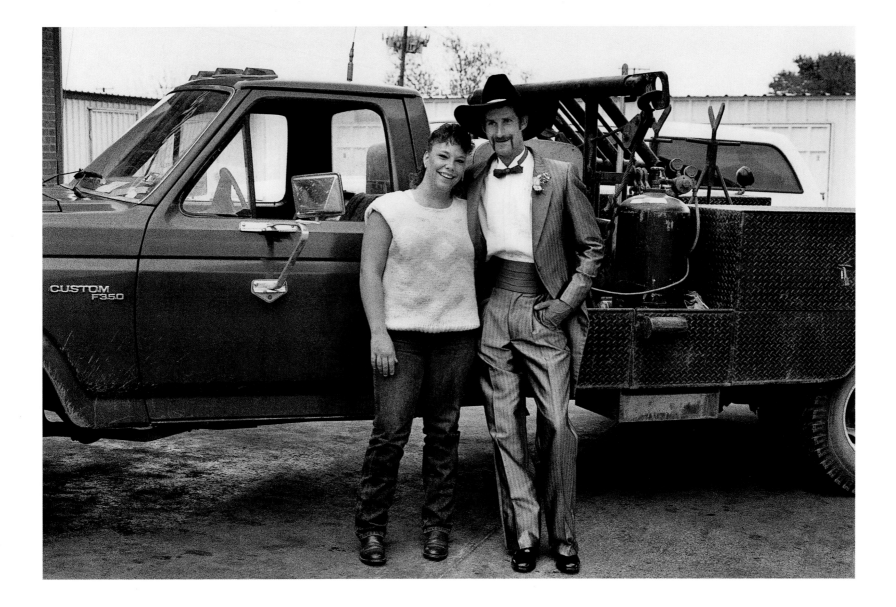

I met Krol on the street in Tashkent. He admired my Leica camera and wanted to know if he could look at it, as he was a local photographer. He took it in his hand and turned it over and over; finally he took his own camera and photographed it. I invited him to bring his wife by my hotel for a beer, and he was pleased to come. Later we went to his house and saw his darkroom and equipment. He loaned me his Russian Horizon camera, and the next day we went together and photographed in the Bukhara market. That evening we went to his darkroom and developed his film. Already on his wall was a poster containing a photograph of mine that I had given him the day before.

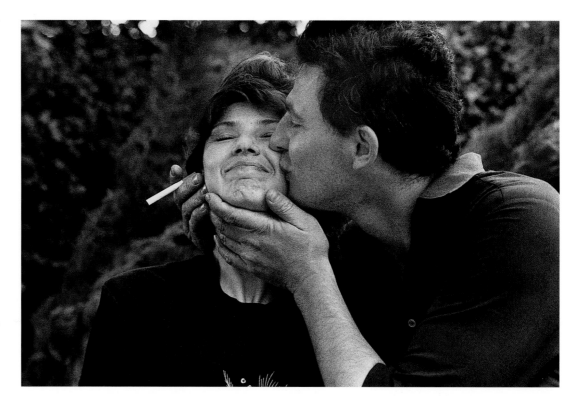

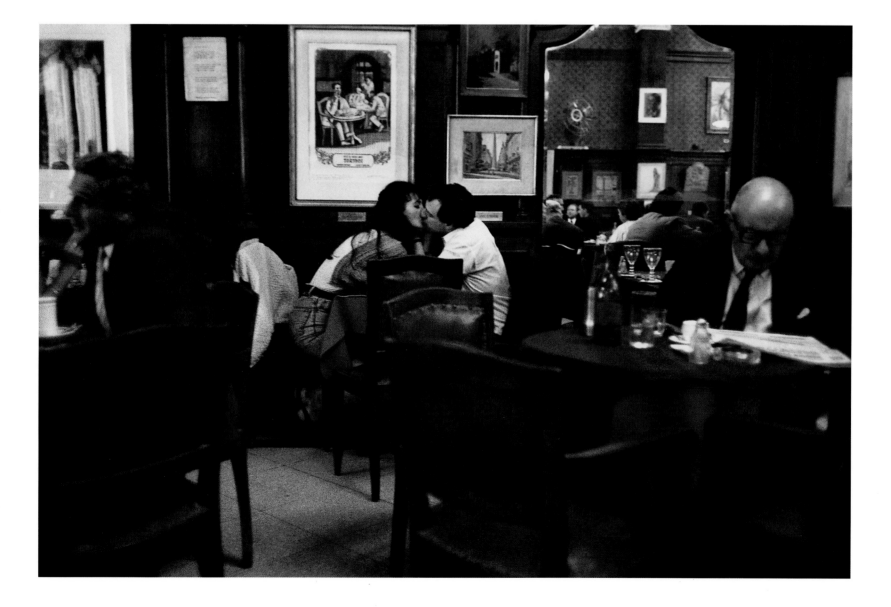

Tumulke village is on the border of one of the largest freshwater marshes in the world, and the inhabitants are mostly fishermen and their families. The boat looks stranded on an immense prairie, but actually there is a network of interconnecting channels meandering through the marsh.

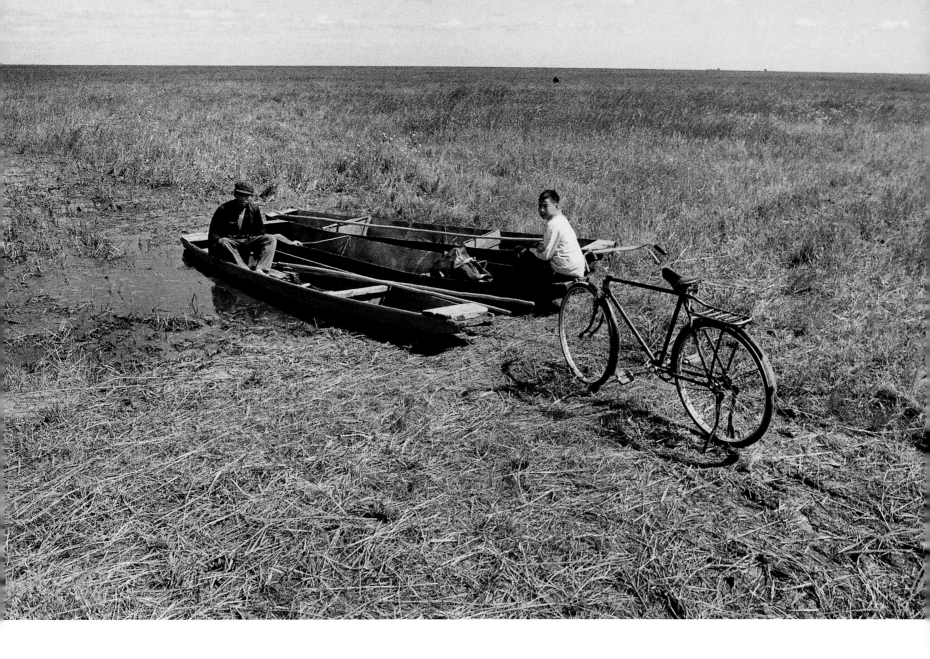

Good photographic opportunities happen early in the morning. Before daylight in Katmandu, I left the hotel and met my friend Nima for a drive into the countryside. As day was breaking, I saw these three men bringing fodder to their animals. They appeared as apparitions in the fog-shrouded road, greeting me as they passed.

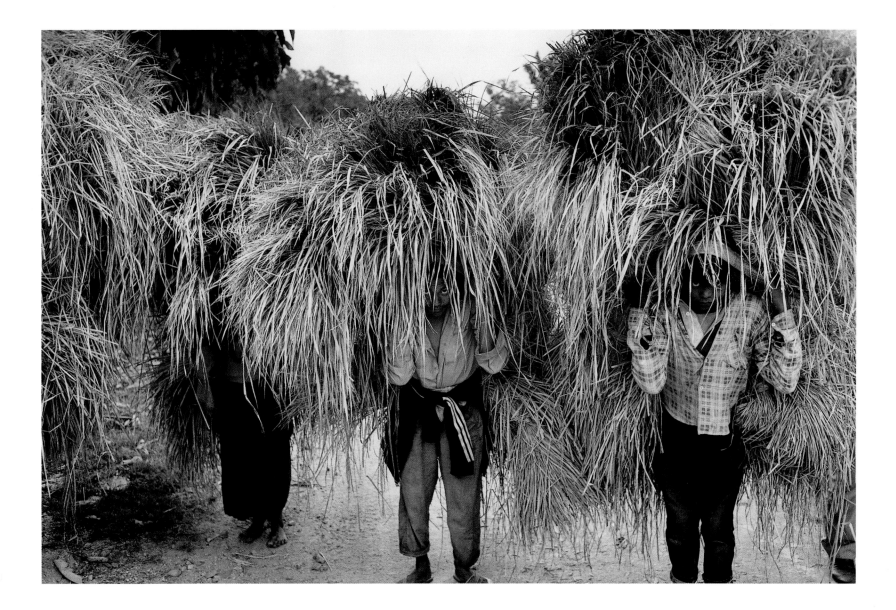

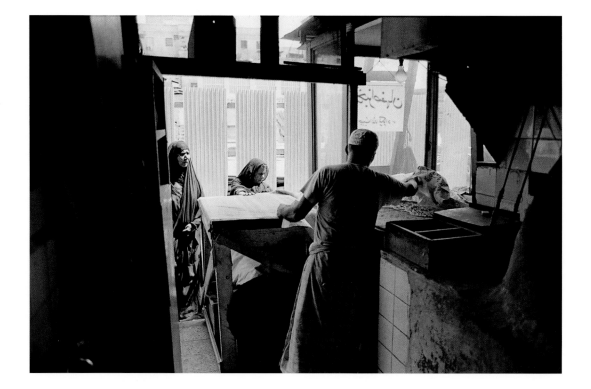

Baker, Dubai, United Arab Emirates, 1984

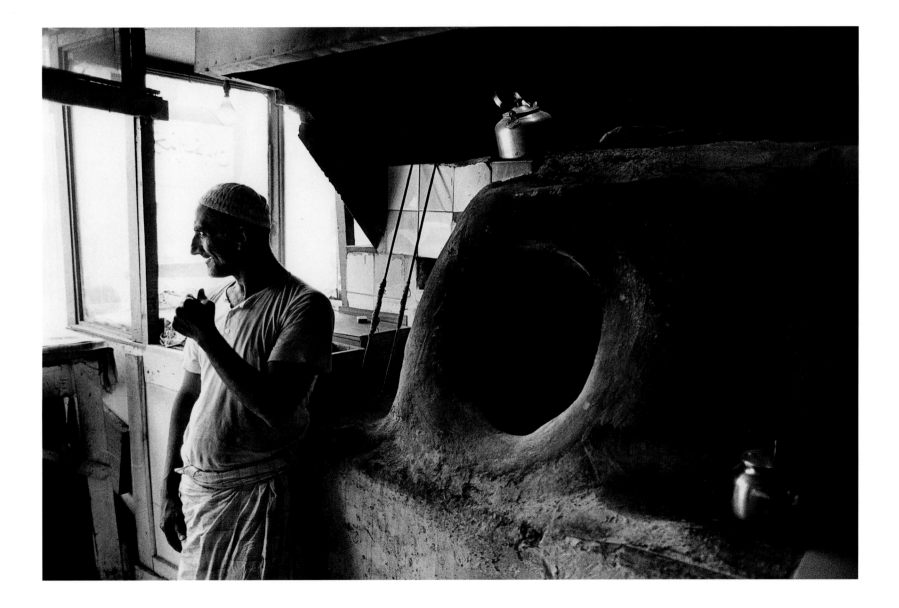

94

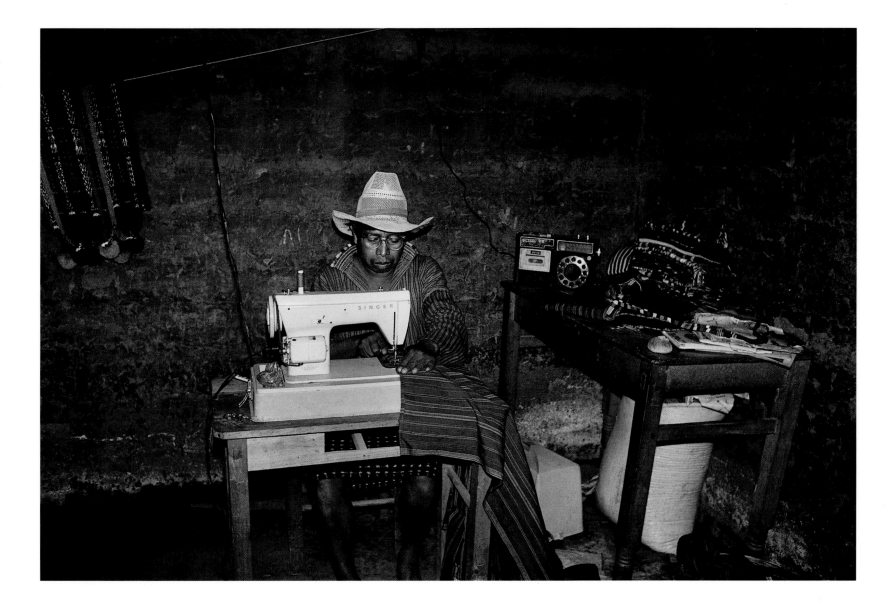

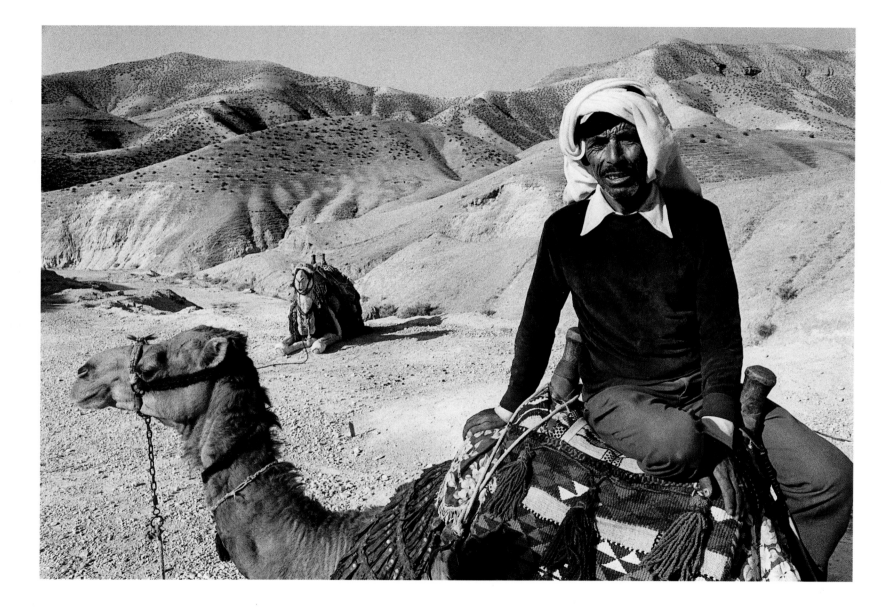

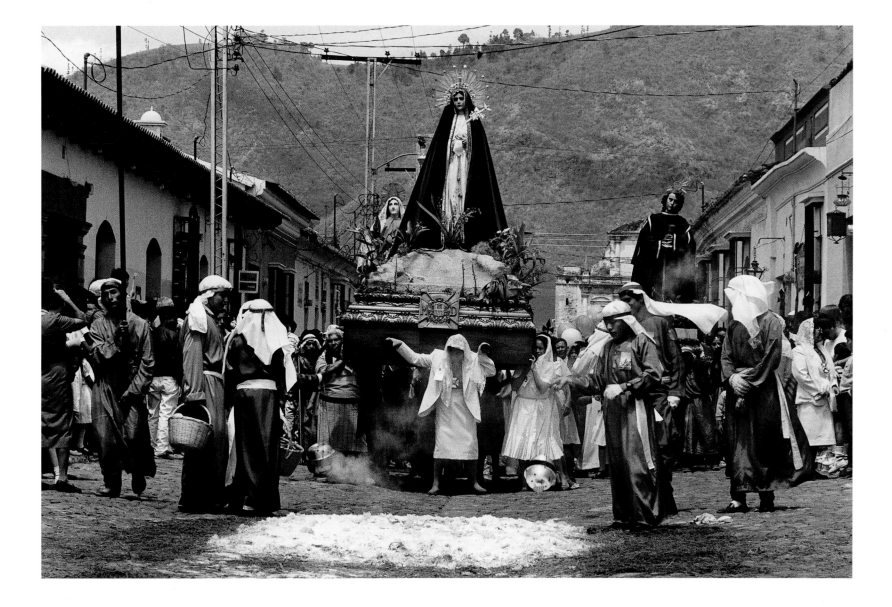

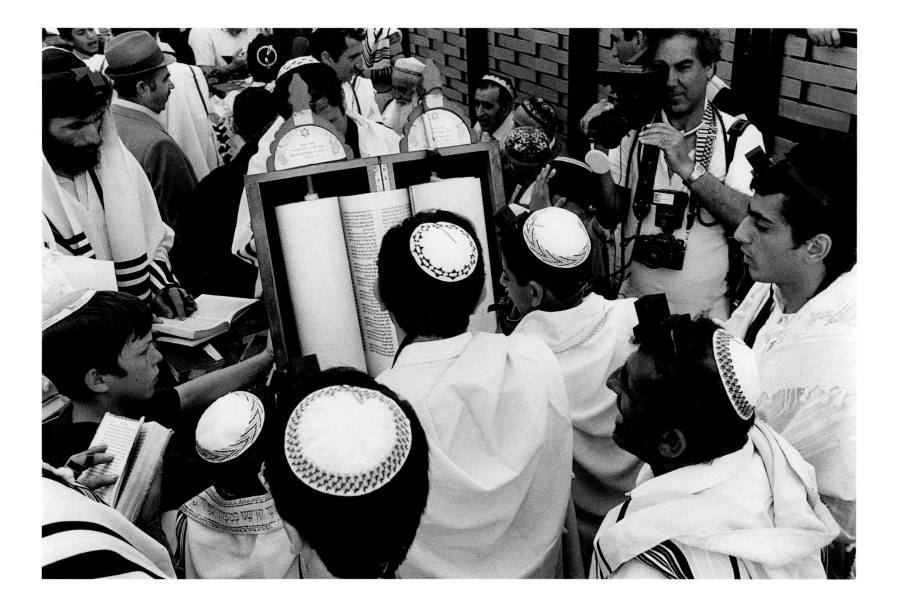

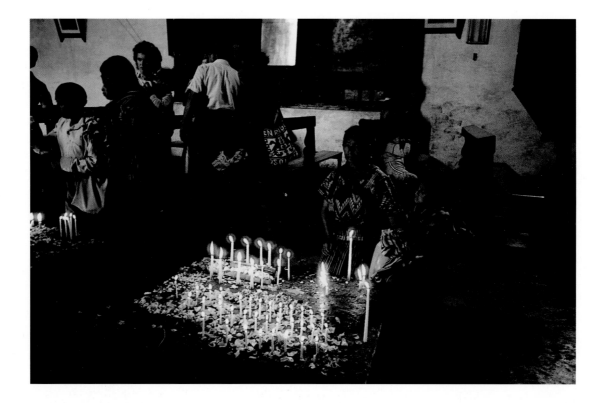

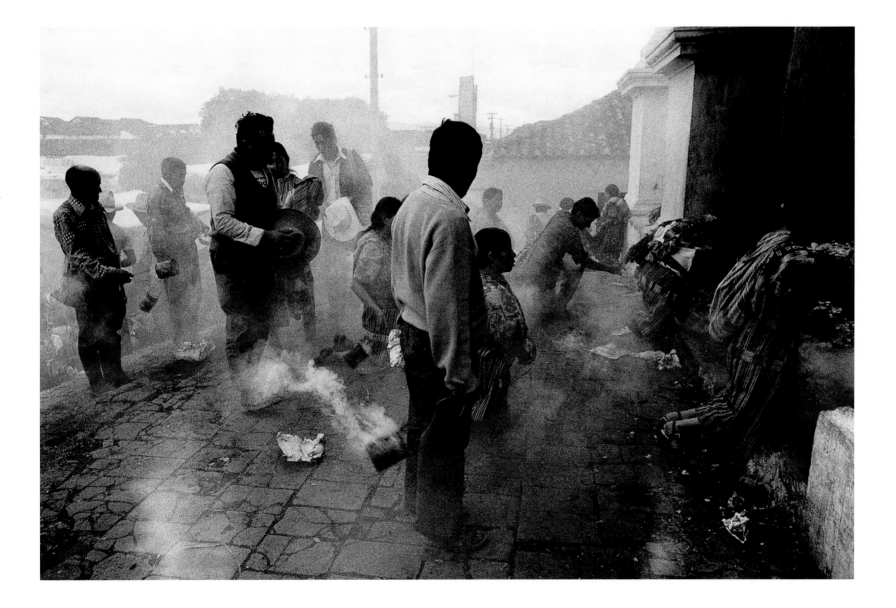

Alice and I were walking through some small shops where local handcrafts were sold. This woman and her baby paused in the doorway. The light and the mother were beautiful. Before I could ask her for a mailing address to send a photo, she was gone.

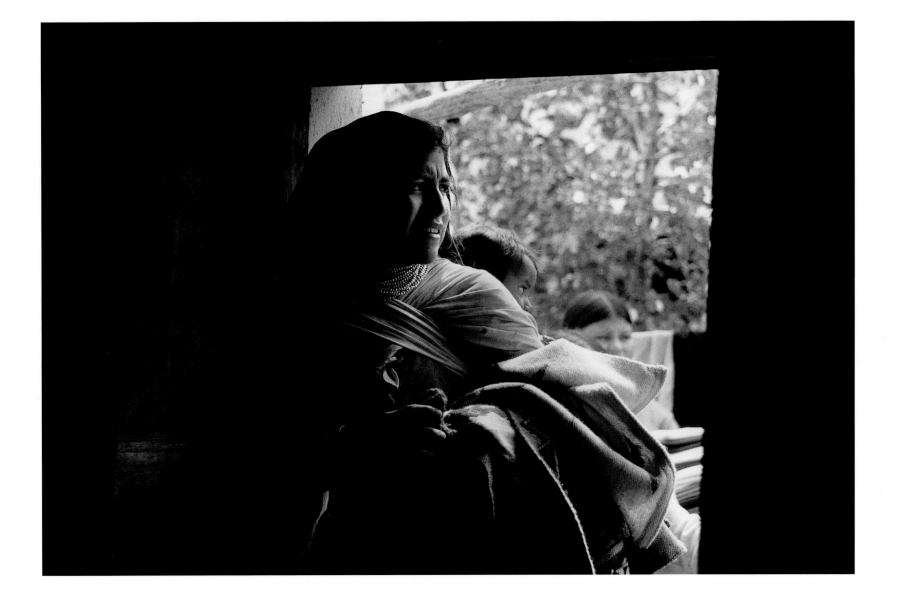

I traveled to Moscow under the auspices of the University of Texas to assist some Russian photographers and curators in establishing a museum of contemporary Russian photography. The effort was spearheaded by Evgeny Berezner, and our meetings were held in his home. His wife, Olga, and their daughter, Nina, prepared meals for us as we reviewed the work of dozens of Russian photographers. Their warmth and generosity made us feel right at home. The character of Moscow had changed considerably since my first visit in 1989. The streets were bustling, and there was merchandise in the shops.

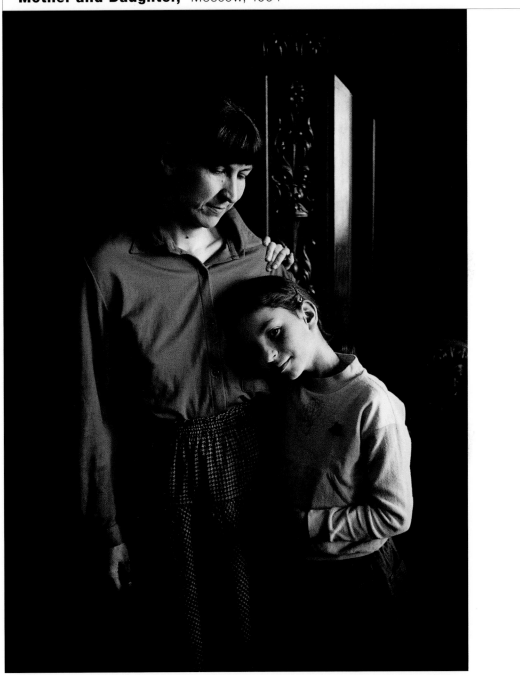

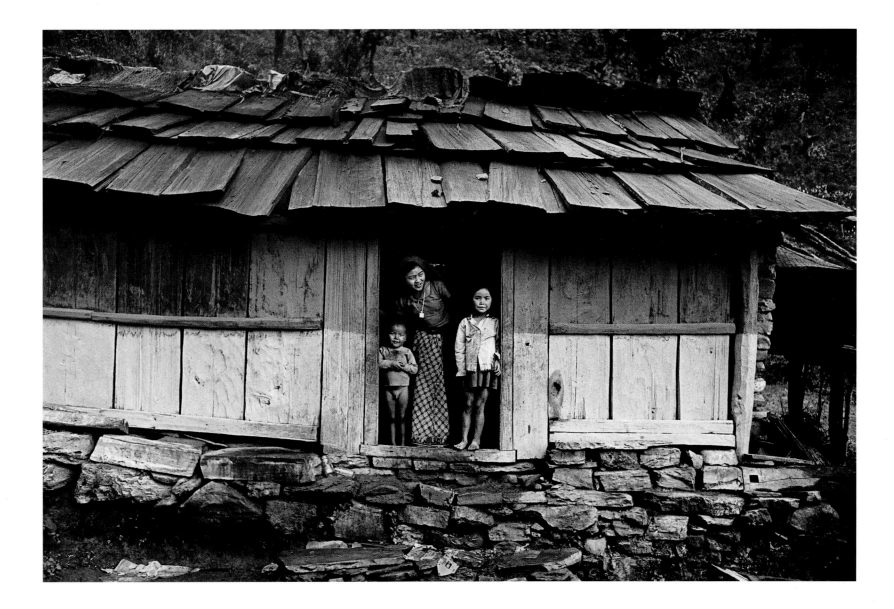

While walking through a village near Katmandu, I came across this young girl who seemed to be trying to decide which way to go. Nepal was undergoing some transition at this time. Students were demanding more democracy, and the king had been making some concessions. The wall graffiti mirror the perplexities faced by the young people of this beautiful, mystical country.

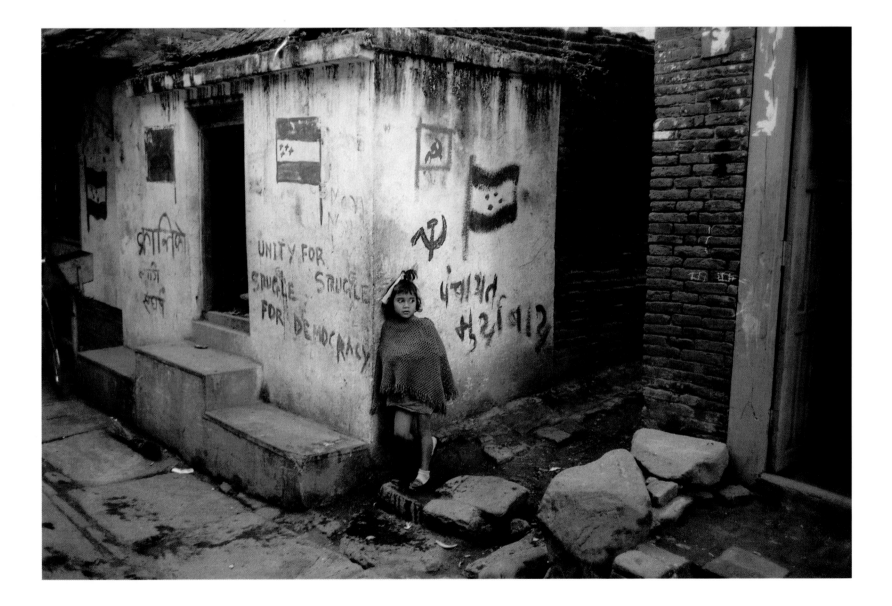

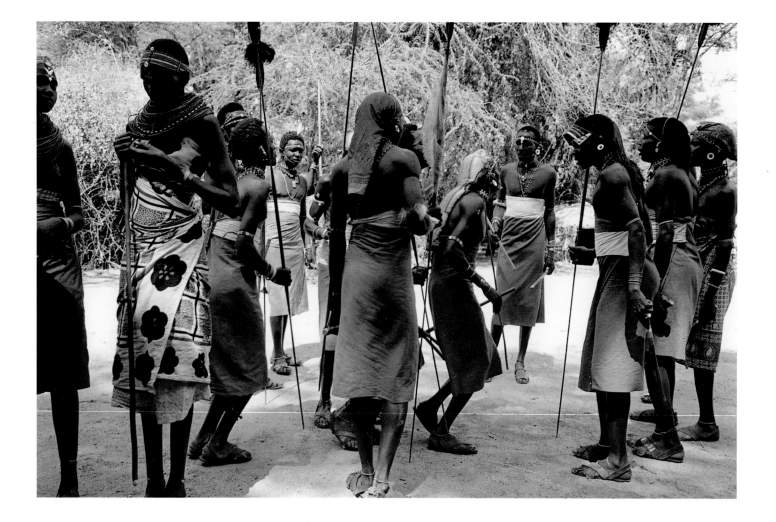

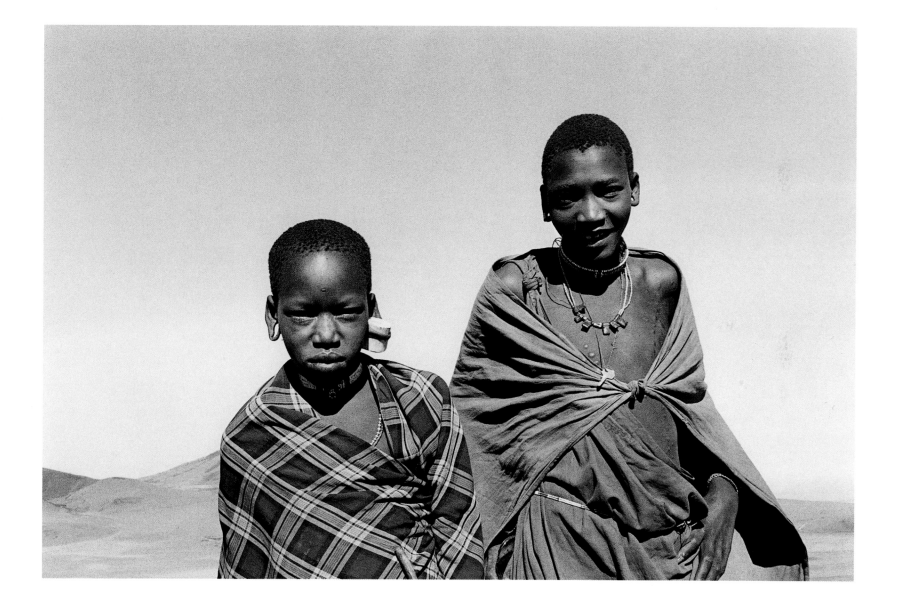

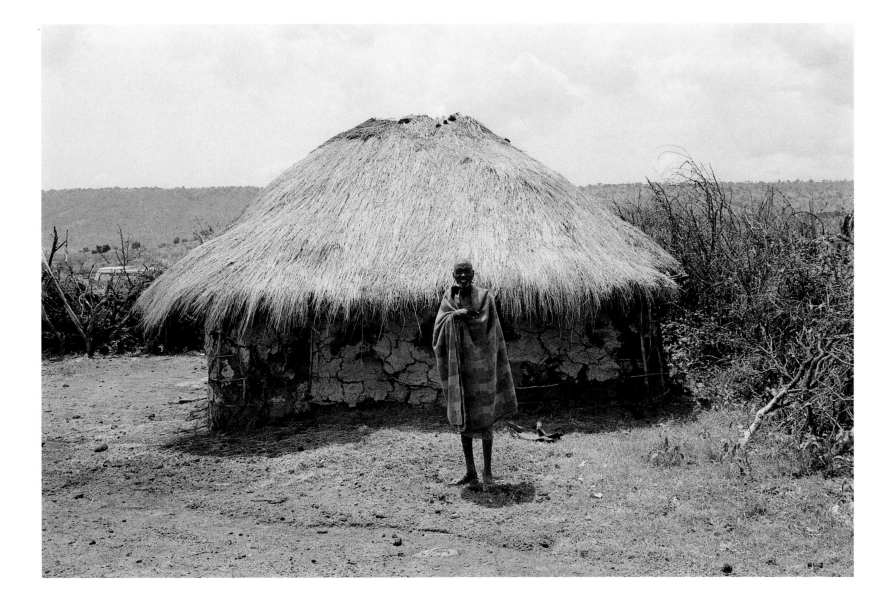

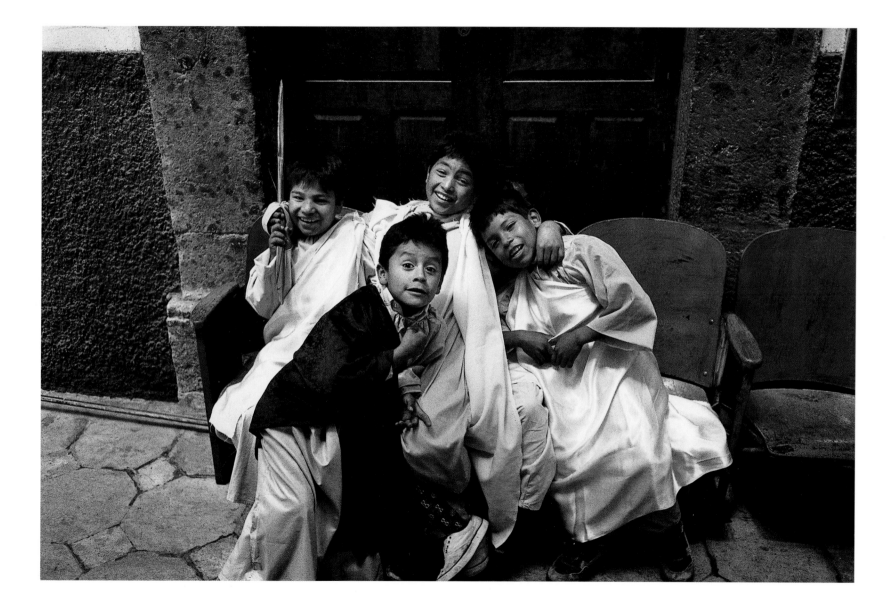

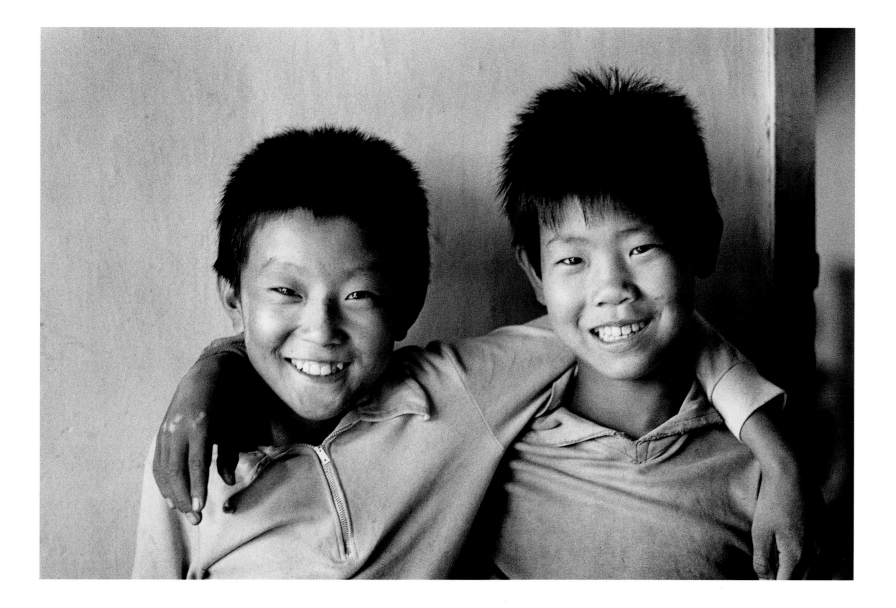

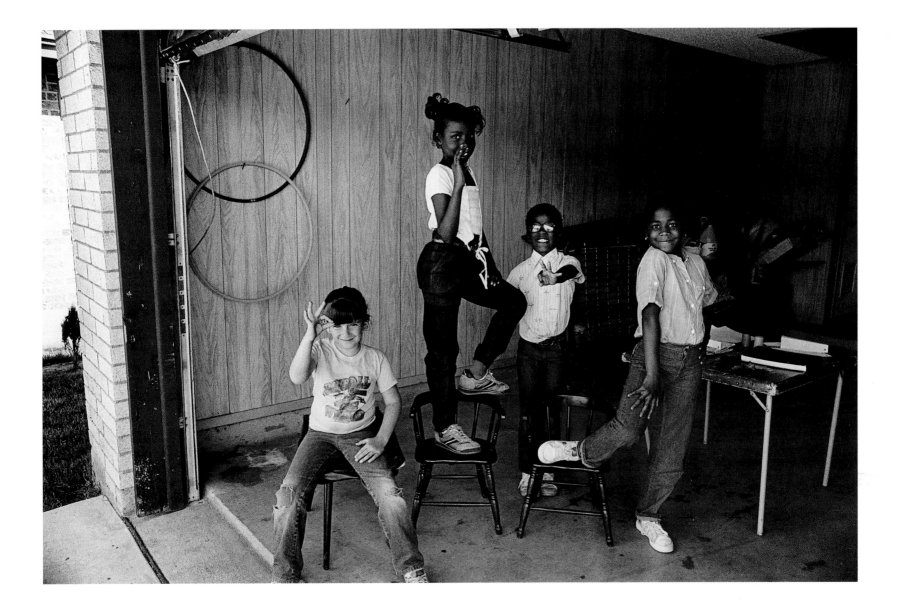

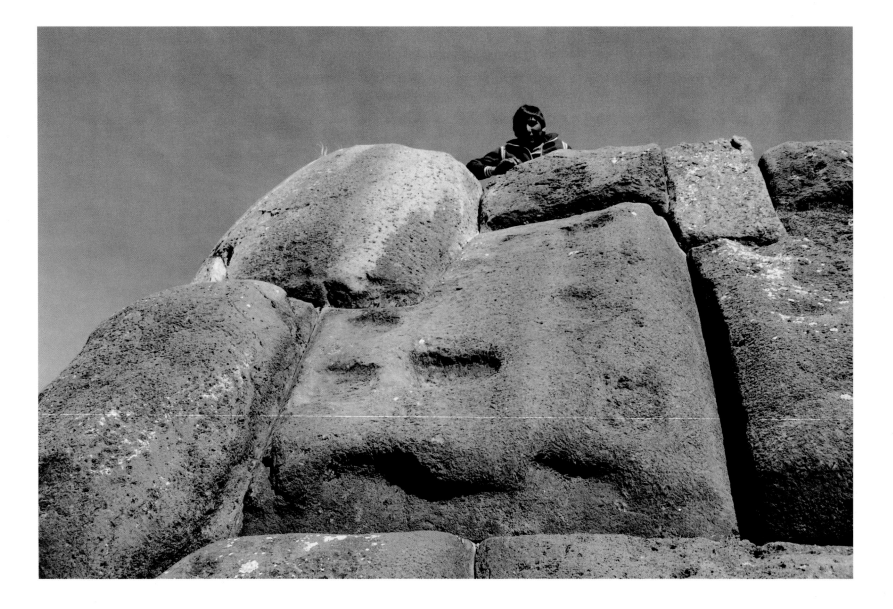

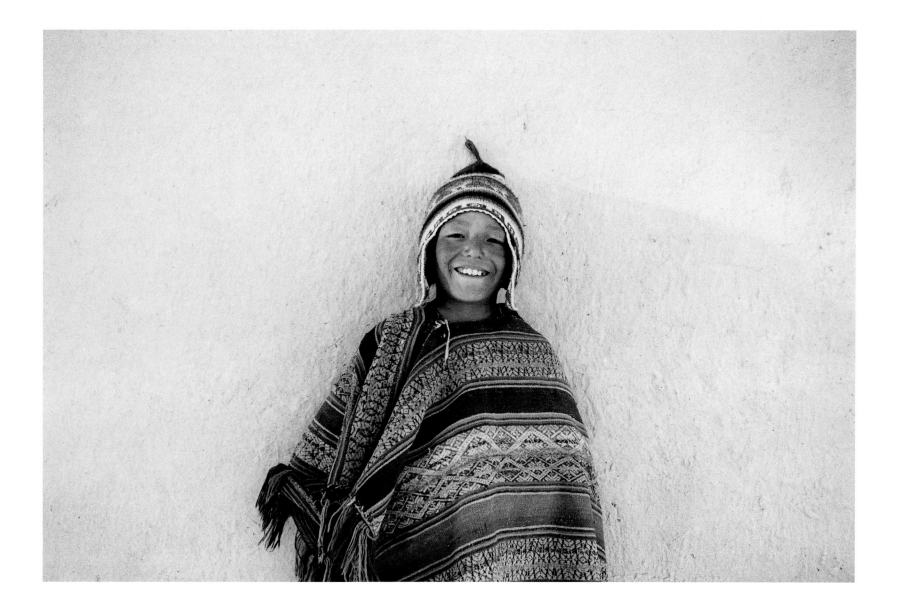

Where the Rio Grande makes a "big bend" in the southwestern part of Texas is one of the most interesting places in America. The blend of cultures—Mexican on the south side and U.S. American on the north—creates a mix that is both fascinating and complex. This young man was riding back to the Mexican village of San Carlos from Lajitas on the Texas side. His father peered into the rear of the vehicle as I was making the photograph. They later drove across the river where Comanche Indians crossed their horses into Mexico during the latter part of the nineteenth century.

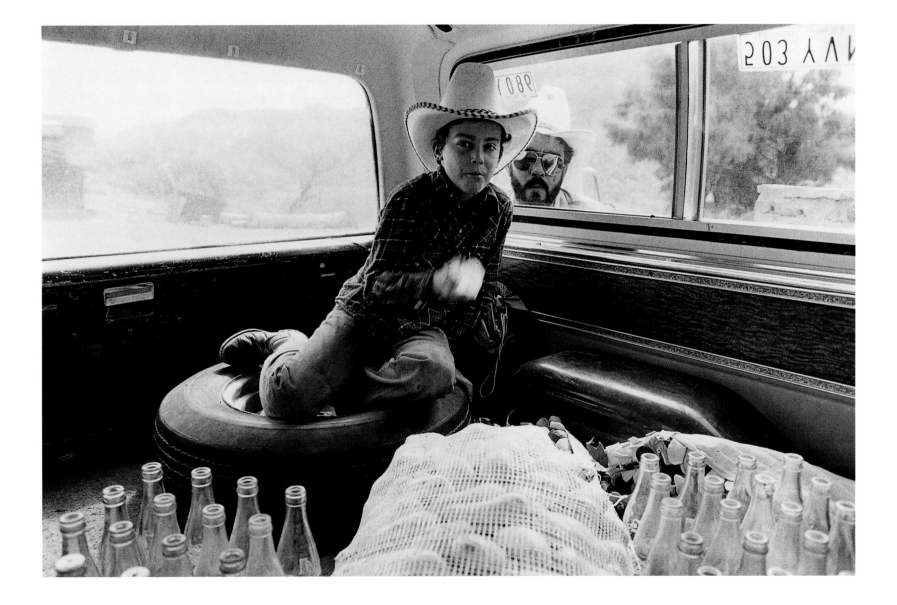

While walking through the streets in Old Havana, I saw a beautiful old American car parked on a side street. A man was polishing it with considerable pride. I stopped and complimented him on the car and asked if I could photograph him with it. While we were working this out, his two daughters appeared at the door of his apartment with their German shepherd puppies. They were laughing and playing with them, and I immediately shifted my attention to them. They picked up the wiggly puppies and were having a ball trying to hold them while I made a picture. We were all laughing when it was over. A good lesson: one photographic opportunity often leads to another!

Girls and Their Dogs, Havana, Cuba, 1998

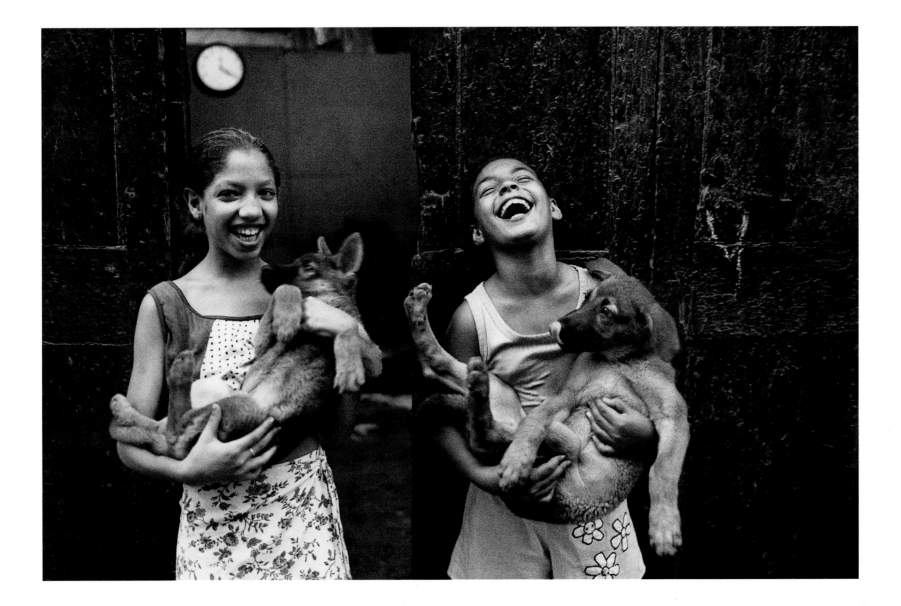

These two older girls were watching the young girl when I walked by. I asked if I might photograph them, and they turned all giggly. The young girl stepped right up and posed.

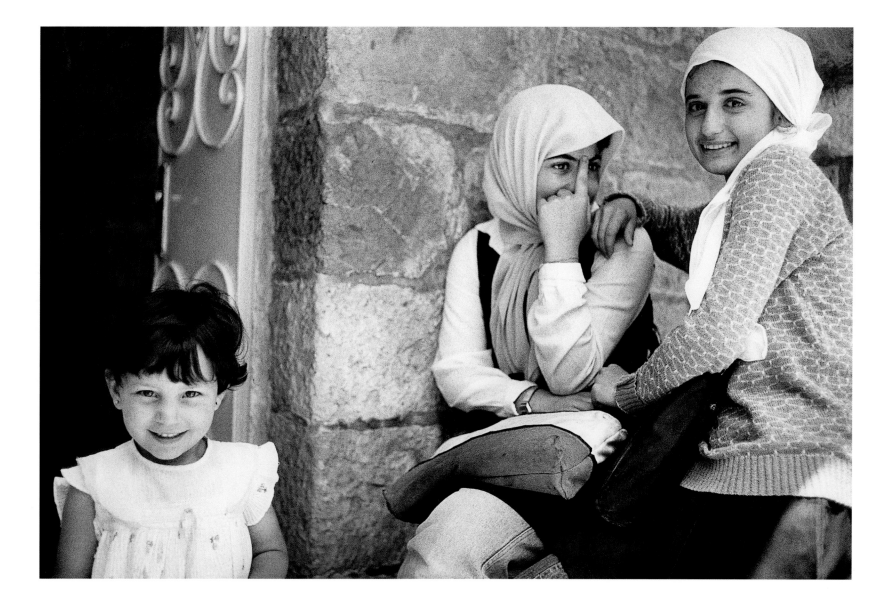

During a trip to Australia, I made arrangements to travel to Fregon Community, an Aboriginal settlement about an hour's flight from Alice Springs. Our light plane landed on a grass strip near the village, and the official government supervisor of the settlement met me. I photographed there for the day, and these energetic young girls did the latest dance for me.

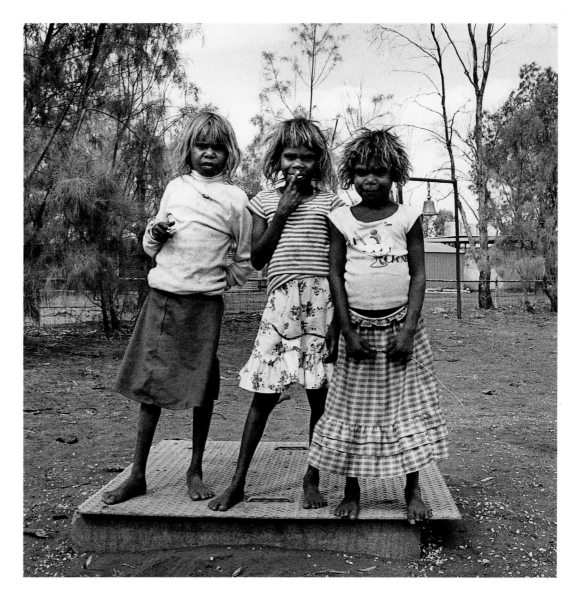

Havana, Cuba, 1998

The last night in Cuba I wanted to attend the famous Tropicana floor show and went to secure tickets from a local hotel concierge. The beautiful young Cuban woman who handled the tickets was full of life and personality; she could have been a movie star. I left Cuba with a new respect for the Cuban people and with hopes that some- day their freedoms and economic opportunities would be restored.

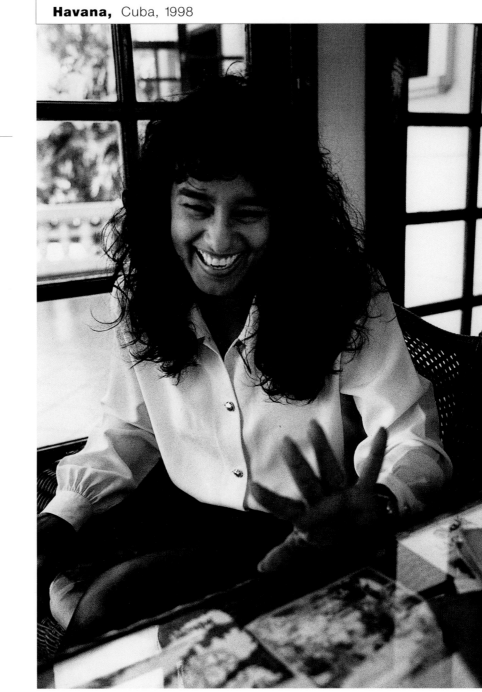

Acknowledgments

I have many people to thank for this book. Foremost are the subjects themselves who permitted me to photograph them where they lived, doing what they were doing, without the advantage of preparation. They opened a small part of their lives to me, and for that I am deeply grateful. My wife, Alice, accompanied me on many of my photographic expeditions, and without her support, my life in photography would have been much more difficult.

I have had many mentors. Roy Flukinger, Curator of Photographs at the Harry Ransom Humanities Research Center of the University of Texas at Austin, has encouraged me over the length of the project and has seen it grow from a dream into a viable idea. Sam Abell, a photographer's photographer on staff at *National Geographic* magazine, was kind and generous in his introduction to this book. He helped develop an idea into a concrete project as he has for so many other photographers. I am indebted to Tom Southall, Curator of Photographs at the High Museum of Art in Atlanta, Georgia, for his supportive criticism and encouragement, and also to Barbara McCandless, Curator of Photographs at the Amon Carter Museum in Fort Worth, Texas. The title of the book developed from a suggestion by Anne Tucker, Curator of Photographs at the Museum of Fine Arts in Houston. Steve Yates, Curator of Photography at the Museum of New Mexico, made important suggestions.

I am very grateful to Angie Cook, my talented assistant, who managed the details of manuscript revision, caption research, negative filing, correspondence, and all the other minutiae that are involved in a project of this kind. Beverly Guthrie, my loyal business manager, played a crucial role by keeping my office running smoothly as I traveled about the world.

The reproduction prints for the book were made by Patrick Jablonski on Agfa Insigna fiber-based paper, and he flawlessly interpreted each negative in perfect concert with my own vision. I am grateful to Agfa for their generous support of this project and the traveling exhibition that accompanies it.

Acknowledgments

Finally, no project of this nature could be successfully completed without excellent editors. Shannon Davies, with whom I have done many projects, skillfully guided me throughout the process with gentle but accurate suggestions for improvement. I appreciate her both as a consummate professional and as a personal friend. I want to say thank you to designer George Lenox and to the staff at the University of Texas Press, especially Theresa May, Carolyn Wylie, and Teresa Wingfield, who have been wonderful to work with on this and other occasions.

Bill Wright

About Bill Wright

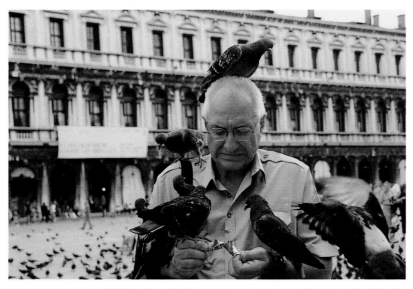

Bill Wright at St. Mark's Square, Venice. Photo by Alice Wright

Born: Harlingen, Texas, April 2, 1933
Educated:
 University of Texas at Austin, Bachelor of Business Administration, 1956
Attended the photographic workshops of:
 Ansel Adams, John Sexton, Jerry Uelsmann, George Krause,
 Cole Weston, Ray Metzker, Bruce Barnbaum, Sam Abell,
 Mary Ellen Mark, Neveda Weir

PHOTOGRAPHS

Collections

 Amon Carter Museum, Fort Worth, Texas
 The British Library, London, England
 Harry Ransom Humanities Research Center, University of Texas at
 Austin, Austin, Texas
 Institute of Texan Cultures, San Antonio, Texas
 Museet for Fotojust, Brandst Klaedefabrik, Copenhagen, Denmark
 Museum of Fine Arts, Houston, Texas
 Museum of New Mexico, Santa Fe, New Mexico
 The National Archives, Washington, D.C.
 National Museum of American Art, Washington, D.C.
 Newberry Library, Chicago, Illinois
 Old Jail Museum, Albany, Texas
 Princeton Collections of Western Americana, Princeton University
 Library, Princeton, New Jersey
 Rijksmuseum voor Volkenkunde, Leiden, The Netherlands
 Rockwell Museum, Corning, New York
 Smithsonian Institution Anthropology Archives, Washington, D.C.
 Tarrant County Junior College, Fort Worth, Texas
 Wittliff Gallery of Southwestern & Mexican Photography,
 Southwest Texas State University, San Marcos, Texas
 Umeleckoprumyslove Museum, Prague, Czechoslovakia
 University of Texas at Arlington, Arlington, Texas

Solo Exhibitions

1977 Abilene Fine Arts Museum, Abilene, Texas
1979 Scurry County Museum, Snyder, Texas
 Amarillo College, Amarillo, Texas
1982 School of American Research, Santa Fe, New Mexico
1983 Photographers' Workshop, Oxford, England

1984	Corridor Gallery, Glenrothes, Scotland
	Fife House, Glenrothes, Scotland
	Tarrant County Junior College, Fort Worth, Texas
1985	Artists' League of Texas, Abilene, Texas
	Accent Gallery, Austin, Texas
	Museum of the Southwest, Midland, Texas
1986	Midland College, Midland, Texas
	Galería de la Acequia, San Antonio, Texas
1992	Collin County Community College, Plano, Texas
	Kilgore College, Kilgore, Texas
1993	United States Information Agency, Washington, D.C.
	Sul Ross State University, Alpine, Texas
	Centennial Museum, El Paso, Texas
1994	Institute of Texan Cultures, San Antonio, Texas
	Parks & Recreation Department, Corpus Christi, Texas
1995	Parks & Recreation Department, Corpus Christi, Texas
	Fulwiler Jewelers, Abilene, Texas
1996	Photographic Archives Gallery, Dallas, Texas
1997	Texas Lutheran College, Seguin, Texas
	St. John's College, Santa Fe, New Mexico
	Institute of Texan Cultures, San Antonio, Texas
	Center for American History, University of Texas, Austin, Texas
	Centennial Museum, El Paso, Texas
1998	Museum of the Big Bend, Alpine, Texas
	O'Kane Gallery, University of Houston–Downtown, Houston, Texas
	The Grace Cultural Center, Abilene, Texas
	Stephen L. Clark Gallery, Austin, Texas
	Environmental Protection Agency, Dallas, Texas
1999	Irving Arts Center, Irving, Texas
	Office of International Affairs, Texas Tech University, Lubbock, Texas
	Centennial Museum, El Paso, Texas
	National Humanities Center, Research Triangle, North Carolina
	Gensler Gallery, Pennzoil Building, Houston, Texas
2000	Institute of Texan Cultures, San Antonio, Texas (scheduled)
2001	Photographs Do Not Bend Gallery, Dallas, Texas (scheduled)

Juried Group Exhibitions

1982	*States of Texas Juried Exhibition,* Allen Street Gallery, Dallas, Texas
1983	*Big Bend Juried Exhibition,* Gallery 104, Austin, Texas
1984	Photoworks Gallery, Austin, Texas
	Photo/Flow National Juried Exhibition, University of Texas at Arlington, Arlington, Texas
	Annual Juried Exhibition, Houston Center for Photography, Houston, Texas
1985	Sangre de Cristo Art Center, Pueblo, Colorado
1986	*People in Places,* Allen Street Gallery, Dallas, Texas
	Texas March 2, State Capitol Galleries, Austin, Texas
1987	*Members Only Exhibition,* Texas Photographers Society, Austin, Texas
1992	*Viewpoint 1992,* Bosque County Conservatory of Fine Arts, Clifton, Texas
1993	Annual Juried Exhibition, Houston Center for Photography, Houston, Texas
	Illuminance, Lubbock Fine Arts Center, Lubbock, Texas
1994	Annual Juried Show, Clifton, Texas
	Members Only Exhibition, Texas Photographers Society, Austin, Texas
	Viewpoint 1994, Bosque County Conservatory of Fine Arts, Clifton, Texas
1995	*Members Only Exhibition,* Texas Photographers Society, Austin, Texas
1996	*Viewpoint 1996,* Bosque County Conservatory of Fine Arts, Clifton, Texas
	Illuminance, Lubbock Fine Arts Center, Lubbock, Texas
1997	*Illuminance,* Lubbock Fine Arts Center, Lubbock, Texas
1999	*Members Only Exhibition,* Texas Photographers Society, Austin, Texas

Traveling Group Exhibitions

1983	Victoria Regional Museum Association, Victoria, Texas
	Cultural Arts Center, Plano, Texas
1986	*Ten Texas Photographers,* Abilene Fine Arts Museum, Abilene, Texas
	The Book of Days, Dorsoduro Press, Austin, Texas

1988 *The Book of Days,* Dorsoduro Press, Austin, Texas
1989 *The Book of Days,* Dorsoduro Press, Austin, Texas
1990 *Ten West Texas Photographers* (including Kiev, USSR)
1994 *ASMP Top 40,* Austin/San Antonio Members Show, American Society
 of Media Photographers
 The Book of Days, Dorsoduro Press, Austin, Texas
1995 *The Book of Days,* Dorsoduro Press, Austin, Texas

Other Group Exhibitions

1983 Old Jail Foundation, Albany, Texas
1985 Southern Light Gallery, Amarillo, Texas
 Texas Tech University, Lubbock, Texas
 University of St. Andrews, Scotland
 Photography and the West: The 80s, The Rockwell Museum,
 Corning, New York
1986 *Texas 150—New Texas Photography,* Houston Center for
 Photography, Houston, Texas
1987 *New Faces,* Allen Street Gallery, Dallas, Texas
1989 *Visions of Texans,* Mexico City, Mexico
1990 *Fotofest,* Houston, Texas
 Annual Christmas Exhibition, Old Jail Museum, Albany, Texas
1991 Old Jail Museum, Albany, Texas
 3 West Texas Artists, Abilene Fine Arts Museum, Abilene, Texas
1993 *State of the Art '93,* New England Fine Art Institute, Boston,
 Massachusetts
1994 *Through a Photographer's Eye,* Philbrook Museum of Art, Tulsa,
 Oklahoma
 Fourth Annual Photography Exhibition, Maryland Federation of Art
 50th Annual Museums of Abilene, Abilene, Texas
1994–1998 Annual Governor's Show, Texas Photographic Society,
 Austin, Texas
1995 First Annual Spring Photography Exhibition, The Image Gallery,
 Longview, Texas
 51st Annual Museums of Abilene, Abilene, Texas

Photospiva '95, George A. Spiva Center for the Arts, Joplin, Missouri
1996 PhotoView Invitational, Longview Art Museum, Longview, Texas
1997 PhotoView 1996 Winners' Exhibition, Longview Art Museum,
 Longview, Texas
 Fourth Annual International Photography Competition and Exhibition,
 San Miguel de Allende, Mexico
1998 *Empires: Russia Past and Present,* Center for Contemporary Arts,
 Abilene, Texas

PUBLICATIONS

Books

1993 *The Tiguas: Pueblo Indians of Texas* (El Paso: Texas Western Press)
1996 *The Texas Kickapoo: Keepers of Tradition* (El Paso: Texas Western
 Press)
1998 *Portraits from the Desert: Bill Wright's Big Bend* (Austin: University of
 Texas Press)
2001 *People's Lives: A Photographic Celebration of the Human Spirit*
 (Austin: University of Texas Press)

Books and Catalogs (Other Than Those by Bill Wright)

1982 *Abilene: An American Centennial* (Abilene: Rupert N. Richardson
 Press, Hardin-Simmons University)
1983, 1985, 1988, 1989, 1994 *The Book of Days* (Austin: Dorsoduro Press)
1989 *Visions of Texans* (catalog, *Visions of Texans* exhibit, Mexico City,
 Mexico)
1993 *Stray Tales of the Big Bend, Texas* (College Station: Texas A&M
 University Press)
1994 *The Photograph and the American Indian* (Princeton, New Jersey:
 Princeton University Press)
1995 *National Parks of North America: Canada, United States, Mexico*
 (Washington, D.C.: National Geographic Society)

Periodicals

August–September 1967 "Paint Rock Indian Art Gallery," *This Is West Texas* 1: 26–27

January 1968 "Abilene Builds a Zoo," *Texas Parade* 27: 17–18

January–February 1968 "Primitive Forest Beauty: Capote Falls," *This Is West Texas* 1: 4–6

March 1969 "Chili Bowl Fly-In," *The AOPA Pilot* 12: 116–118

July–August 1969 "The River Run: Mariscal Canyon Float Trip," *This Is West Texas* 3: 10–14

November–December 1969 "Frio Canyon: Kid Country," *This Is West Texas* 3: 14–15

January–February 1971 "Float Trip down the Rio Grande," *This Is West Texas* 4: 17–19

Fall 1992 "The Tigua Pueblo Indians of Texas: A Resilient American Culture," *Heritage: A Publication of the Texas Historical Foundation* 10: 18–22

1995 *The Photo Magazine of the Confederation of Journalists Unions*

June 1996 "What Do You Get from a Workshop? Eight Students Tell What They Learned from Sam Abell in Santa Fe," by Dan Richards, *Popular Photography* 60: 69

April 5, 1998 "The New Cuba," *Abilene Reporter-News Sunday Life Section*

June 26, 1998 "Landscape of Our Lives," End Paper, *The Chronicle for Higher Education* 44: B64

April 2000 "People's Lives: Celebrating the Human Spirit," *Ideas from the National Humanities Center* 7:54–59

Periodicals (Photographs Only)

Spring 1984 *Photo Letter: A Publication of the Texas Photographic Society* 5

Winter 1986 *Spot: A Publication of the Houston Center for Photography* 4

1992 Community Foundation of Abilene, *1992 Annual Report*

1994 "In Morocco: On a 'No Margin for Error Assignment'" by Joe Gioia, *Nikon World* 5

Community Foundation of Abilene, *1995 Annual Report*

Winter 1996 *New Mexico Photographer* 4

Summer 1996 *New Mexico Photographer* 4

October 1998 *Outside Magazine's Travel Guide*

June 1999 *Travel Holiday* 182

WORKSHOPS CONDUCTED

1990 Southwest Photo Workshop, San Miguel de Allende, Mexico

1991 Weslaco Independent School District, workshop in general photography

Collin County Community College, workshop in documentary photography

1992 Southwest Photo Workshop, Big Bend National Park

1993 Collin County Community College, workshop in documentary photography

Southwest Photo Workshop, Big Bend National Park

1994 Southwest Photo Workshop, Guatemala

1998 Santa Fe Photographic Workshop, Big Bend National Park

1999 Santa Fe Photographic Workshop, Big Bend National Park

2000 Santa Fe Photographic Workshop, Big Bend National Park

LECTURES

1985 "Documentary Photography," Museum of the Southwest, Midland, Texas

1989 "History of Photography," Hardin-Simmons University, Abilene, Texas

1993 "Soviet Photography," University of Tulsa, Tulsa, Oklahoma

"Documentary Photography," University of Texas at El Paso, El Paso, Texas

1994 "Documentary Photography," Institute of Texan Cultures, San Antonio, Texas

"Soviet Photography," Texas Tech University, Lubbock, Texas

1994, 1995, 1996 "The Photographic Project," Santa Fe Photographic
 Workshop, Santa Fe, New Mexico
1995 "The Photographic Project," Houston Center for Photography,
 Houston, Texas
 "About My Photography," Museum of Fine Arts, Houston, Texas
1996 "About My Photography," Caprock Photographic Society, Lubbock,
 Texas
 "The Kickapoo Project," Photo Archives Gallery, Dallas, Texas
 "The Photographic Project," Caprock Photographic Society,
 Lubbock, Texas
1999 "Travel Photography," Houston Center for Photographs, Houston,
 Texas

PROJECTS ORGANIZED AND CURATED

1982 Initiated a photographic archive at Hardin-Simmons University with
 the Abilene Cultural Affairs Council, in conjunction with the
 celebration of the Abilene city centennial
1986 Conceived, organized, and secured funding for the books
 Contemporary Texas and *Historic Texas,* published by the Texas
 Monthly Press
1988 *The Peruvians:* Organized an exhibit of seventeen Peruvian
 photographers that toured the United States under the management
 of the Texas Humanities Resource Center
1989 Initiated contacts with the Czechoslovakian ministry of culture on behalf
 of the Texas Photographic Society, resulting in a Czechoslovakian
 documentary exhibit at *Fotofest* '90, Houston, Texas
1990 Organized the exhibition *Ten West Texas Photographers,* which
 opened in Kiev in October 1990 and continues to tour Russia
1991 Organized and curated the exhibition *Soviet Photography,* which
 includes the work of fourteen photographers of the former USSR
 working in a variety of traditions
 Organized *The Scottish Photography Project,* a traveling exhibition
 of Texas photography in Scotland

Selected the photography and prints for the *Scottish Exhibition in
Texas,* Center for Contemporary Art, Abilene, Texas
Curated the exhibition *Geonadi Haryanto, Indonesian Photography*
for the Center of Contemporary Art, Abilene, Texas
1993 Curated the exhibition *Jecko Vassilev, Bulgarian Photographer* for
 the Museums of Abilene, Texas
 Organized the exhibition *The Tiguas: Pueblo Indians of Texas* for travel
 throughout the United States
1994 *1994 Peruvian Project:* Organized a painting and photography
 exhibition for Fernando Torres, Director Cultural, Instituto Cultural
 Peruano, Norteamericano
1994–1995 *The Russian Photographic Collection Project:* Asked to assist
 Roy Flukinger, the American partner for an International Research
 and Exchanges Board grant, in establishing one of the first museum
 collections of contemporary fine art photography in Russia (the
 Russian Museum of Photographic Collections). A duplicate collection
 is housed at the Harry Ransom Humanities Research Center at the
 University of Texas at Austin.
1996 Organized the exhibition *The Texas Kickapoo: Keepers of Tradition* for
 travel throughout the United States
1997 Organized the exhibition *Portraits from the Desert: Bill Wright's Big
 Bend* for travel throughout Texas
1998 Facilitated and participated in the photographic collaboration *Empires:
 Russia Past and Present,* an exhibition of images of Russia before
 and after the fall of Communism, including works by Natasha and
 Valery Cherkashin, Steve Yates, and Bill Wright
1999 Organized the exhibition *People's Lives* for travel throughout the
 United States

AWARDS

1981	Individual Award, Texas Commission on the Arts/Texas Arts Alliance
1984	Best of Show, Artist's League of Texas Group Show, Abilene, Texas
	Honorable Mention, *Travel & Leisure* International Photography Competition (over 10,000 entries)
	Juror's Award, Photo/Flow National Juried Exhibition
1986	First Place, Black/White Fine Arts Division, East Texas International Photo Competition
	Fine Art Photography Award, United States Central Region, Leica Medal of Excellence
1987	First Place, Texas Photographic Society, Austin, Texas (Juror: Paul Caponigro)
	Honorable Mention, Black/White Fine Arts Division, East Texas International Photo Competition
1991	Best of Show, Black/White Fine Arts Division, East Texas International Photo Competition
1993	First and Second Place, Portraits and Human Interest, Caprock Photographic Society Exhibition, Post, Texas
1994	Southern Book Award, Border Library Association, for *The Tiguas: Pueblo Indians of Texas*
	First, Second, and Third Place, Portraits and Human Interest, Caprock Photographic Society Exhibition, Post, Texas
1997	Purchase Prize, *Illuminance* exhibition, Lubbock Fine Arts Center, Lubbock, Texas

MEMBER

American Society of Media Photographers
Board, Center for Photographic Projects, Santa Fe, New Mexico
Board, School of American Research, Santa Fe, New Mexico
Board, Texas State Historical Association
Commissioner, Texas Commission on the Arts
Editorial Advisory Committee, Prothro Series in Photography, Texas A&M University Press
Harry Ransom Humanities Research Center Advisory Council, University of Texas at Austin
National Parks and Conservation Association Advisory Board
National Trust for the Humanities
Philosophical Society of Texas (past president)
Texas Photographic Society Advisory Council
Texas Society of Architects (honorary)
West Texas Photographic Society